Indian Painters of the Southwest

The publication of this book was made possible by generous
funding from the Katrin H. Lamon Endowment for Native
American Art and Education and an anonymous donor.

School of American Research
Contemporary Indian Artists Series

Kathleen Whitaker
Series Editor

Indian Painters of the Southwest

Participating Artists

Michael Kabotie
Hopi

Jeanette Katoney
Navajo

Linda Lomahaftewa
Hopi-Choctaw

Felice Lucero
San Felipe Pueblo

Marcellus Medina
Zia Pueblo

Diane Reyna
Taos Pueblo

Mateo Romero
Cochiti Pueblo

Alex Seotewa
Zuni Pueblo

Emmi Whitehorse
Navajo

Gary Yazzie
Navajo

Indian Painters of the Southwest

The Deep Remembering

Katherin L. Chase
With a Foreword by Diane Reyna

School of American Research Press
Santa Fe, New Mexico OCM 45505977

School of American Research Press
Post Office Box 2188
Santa Fe, New Mexico 87504-2188
www.sarweb.org

Acting Director of Publications: Cynthia Welch
Editor: Joan K. O'Donnell
Copy Editor: Jo Ann Baldinger
Art Direction and Typography: Cynthia Welch
Concept: Edvin Yegir
Printer: Sung In Printing

Library of Congress Cataloging-in-Publication Data:

Chase, Katherin L.
 Indian painters of the Southwest: the deep remembering / Katherin L. Chase.
 p. cm. – (Contemporary Indian artists series)
 Based on a convocation held at the School of American Research, November 2–5, 1998.
 Includes bibliographical references.
 ISBN 0-933452-66-7 (pbk.)
 1. Indian painters—Southwest, New—History. 2. Indian painting—Southwest, New—History. 3. Pueblo artists—History. 4. Pueblo painting—History. I. Title. II. Series.

E78.S8 C53 2001
759.19'089'97—dc21
00-067987

"Sacred Mischief Keepers" is excerpted from the longer poem "Sacred Mischief Keepers," written to commemorate the November 1998 IARC Southwest Indian Painting Convocation, copyright © 1998 Michael Kabotie. Used by permission of the author.

Printed and bound in South Korea.

Contents

Sacred Mischief Keepers

I met the Contrary Clan, striped/cubist Koshare faces; jeans, sweatshirts, and paintbrushes; intellectualizing and DEEP REMEMBERING arts, aesthetics but mainly mischievous issues.

"We do not own anything, especially SPIRITS; they have nooo boundaries, they come and go; through rock, planets, trucks, and paintbrushes!"

I am stunned by the trickster's observation. I ran across these Zennist Clowns in a gathering in New Mexico, and like the spirits in their discussion they resisted boundaries; talking from many angles and Centers.

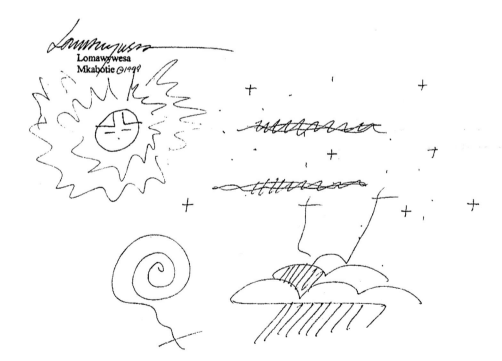

Lomawywesa
Mkabótie ⊙1999

Foreword

This book emerged from a gathering of contemporary Southwestern Native artists—all talented peers and friends—that was guided by the title "The Deep Remembering." This phrase holds profound meaning for me. Defining my role in the world through my images on paper and in stone means always looking back to the cultural experience of the people I was born to. I am part of a continuous evolution of tribal people in this place and time. Cultural memory guides my creative work. I draw from what I know to create the new images, the new reflections of a twenty-first-century Pueblo woman.

What I know of the people who have gone before me is that they possessed endurance, integrity, belief in powers greater than themselves, and a commitment, obligation, and responsibility to the sacred. These elements are necessary ingredients in my own creative work. I am part of a legacy of people who created images and objects to sustain their religious and community life.

My deep remembering is the foundation for my creative work. It is the reference from which I begin to translate my twenty-first-century experiences into form and image. I am in a constant state of remembering.

The images created on paper and stone are extensions of my thought process, my understanding of the world. It is my own private language, conveyed to me by the collective memory of the people I was born to. I translate those thoughts, feelings, and impressions into image and form. I am communicating through these images. My completed work contains images and symbols of rain, corn, mountains, stars, and migration. These are reminders to me always to journey with spiritual nourishment, strength, wonder, and the sacred.

—Diane Reyna

Introduction

The genesis of Native American Indian painting dates back many centuries. Pictographs and petroglyphs in caves and on rock faces are not only the first paintings this continent produced but also the first American paintings in which abstract style and impressions, now commonly associated with contemporary art, were developed to an advanced degree. The arts educator Dorothy Dunn, in her 1968 book *American Indian Painting of the Southwest and Plains Area*, wrote: "Indian painting is New World conceived. It is not an outgrowth of the mature arts of other countries. It contains a rich variety of symbols and forms that are particularly expressive of cultures slowly evolved within a vast new land. It reveals...man's relationship with the unique American environment—the soil and the gigantic terrain, the powerful natural forces, the indigenous substances and beings."

That was the observation thirty-three years ago. Contemporary painting of the Native American Southwest is now charged with changing styles, European influences, and many improvisations layered upon what was once considered traditional, conservative growth. Modern works by Southwestern Indian artists stand as both the equals of and complements to the masterpieces of any other culture. Today, some artists choose to work within the traditional formats and designs of their culture, while others break away from the established parameters of their genre. They experiment with life, and they incorporate individual aspects of the learning process—from childhood to adulthood—into their work. Michael Kabotie says, "There is no agenda for my art—it's my song and dance. I value poets. Chanting, whether Gregorian, Buddhist, or Native American, is important for getting in touch with self."

Many contemporary Native American artists achieve a confidence in the execution of their paintings that makes their virtuosity clear even to the untutored eye. Their work is full of passion and refinement. They are never limited or constrained by boundaries. They look to their ancestors and other Native American as well as European masters for their inspiration. Gary Yazzie, for example, says, "Most of my influences are European; my style is unlike most other Native Americans."

Yazzie and Kabotie are two of ten Native American painters of various cultural backgrounds and training who came together in 1998 for the fourth annual Native American Artist Convocation at the Indian Arts Research Center (IARC) at the School of American Research in Santa Fe, New Mexico. These convocations, which began in 1994 under the leadership of former IARC staff members Duane Anderson and Christy Sturm, offer small groups of respected Indian artists several days in which to

discuss and study their particular medium. As of this writing, the IARC has sponsored seven convocations. In addition to painting, their topics have been micaceous pottery, Pueblo embroidery, mosaic and inlay jewelry, basketry, kachinas, and clay figurative sculpture.

The painting convocation, formally titled "The Deep Remembering: The Art and Aesthetics of Southwestern Indian Painting," was facilitated by participants Diane Reyna and Gary Yazzie, who had both been Ronald and Susan Dubin Native American Artist Fellows at the School of American Research that year. Between them they did a splendid job of keeping the visual and verbal dialogue flowing spiritedly and productively. In addition, IARC research associate Katherin Chase attended the convocation as an observer and recorder of the proceedings, with the ultimate goal of writing this book— another job admirably done. As you will learn in the following pages, the convocation began as a means of learning about modern influences and aesthetic values, but the conversation quickly turned to the passion and the intangible feeling of satisfaction garnered through the creative process. As artists and individuals, the participants exchanged ideas and learned from each other's work. Many of their pieces are magnificently sampled in this publication.

These works demonstrate both similarities and differences among the artists. There are those who eloquently paint their rhythmic geometries and abstract figures into congruence with the rectangular plane of the painting, suppressing the visible acts of the hand, and there are those who paint their world with linear clarity, directness, and a kind of lyrical paean to traditional symbols. No longer can the Native American canvas be annexed to the tenets of tribal, and therefore "primitive," art. It has universal style, character, and appeal, yet it can still be conceived of as an act of integration within Native American culture. Each work confirms the artist's concept of his or her own reality.

The Indian Arts Research Center at the School of American Research is pleased to present the work, aesthetic values, and creative thoughts of Michael Kabotie (Hopi), Jeanette Katoney (Navajo), Linda Lomahaftewa (Hopi-Choctaw), Felice Lucero (San Felipe), Marcellus Medina (Zia), Diane Reyna (Taos), Mateo Romero (Cochiti), Alex Seotewa (Zuni), Emmi Whitehorse (Navajo), and Garry Yazzie (Navajo).

—Kathleen Whitaker, Director
Indian Arts Research Center

Emmi Whitehorse (left) and Diane Reyna

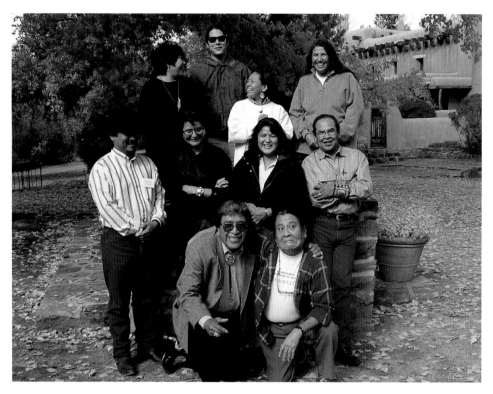

Top row, from left: Linda Lomahaftewa, Mateo Romero, Felice Lucero, Diane Reyna.
Middle row: Marcellus Medina, Emmi Whitehorse, Jeanette Katoney, Gary Yazzie.
Kneeling: Alex Seotewa, Michael Kabotie.

The Convocation

The Deep Remembering: A Convocation of Southwestern Indian Painters

*I am amazed that all of us at this convocation, young and old, are
struggling with the same issues and have a similar goal: to take tradition
and mold it into modern concepts and a universal language. We're not
that far apart, we just have different approaches.*

—Emmi Whitehorse, Navajo

Creativity as a cornerstone of the human condition has long been a central theme of research and studies carried on under the auspices of the School of American Research (SAR) and its Indian Arts Research Center (IARC). The IARC's mission is to study and foster the creativity of Indian people of the American Southwest by making its collections available to scholars and Native American artists and by sponsoring gatherings of contemporary Indian artists working in the same media.

The convocation called "The Deep Remembering: The Art and Aesthetics of Southwestern Indian Painting," held at SAR on November 2–5, 1998, brought together ten artists broadly representative of both the diversity of Southwestern cultural roots and the issues facing Native painters today. The group met daily in the IARC vaults, where they were surrounded by vast collections of Southwestern cultural materials. They were visibly moved by this tangible testimony to their heritage. With abundant evidence of rich traditions on every side, how could a gathering of artists reflecting on their cultural legacy be anything but stimulating?

The discussions began with the artists examining their collective, though diverse, artistic heritage and its evolution through a review of Native American paintings in the IARC collection. For all practical purposes, the Southwestern Indian easel art tradition is an innovation of the twentieth century, barely one hundred years old. The so-called "traditional painters," the young Indians introduced to the easel format in the first decades of the twentieth century, were pioneers forging a new art form from the wellsprings of their own traditions. Implicitly acknowledging that the last one

> "Before this week we knew of one another; now we know one another. We have shared feeling, remembering, laughing."
>
> —Alex Seotewa

hundred years have wrought dramatic changes in the lives of Native Americans on every front, the participants compared and contrasted the lifestyles and expectations of the earlier artists with their own experiences. They were interested, too, in the stylistic developments of the Indian easel art tradition, including the technical aspects of composition, color, and design, as well as subject matter.

The three days of meetings were highlighted by profoundly thoughtful and honest conversations that deeply plumbed each artist's sense of place, self, and the role of Native American traditions in their work. Participants thought seriously about their heritage, asking, "Where have I come from?" They defined themselves for one another by addressing the question, "Who am I?" And they looked into the future, thinking aloud, as Emmi Whitehorse said, about molding tradition to fit their contemporary lives. What emerged were provocative insights and incisive commentary about a dynamic aspect of art in twentieth-century America: Native American creativity and, specifically, its manifestation in the paintings of Southwestern Indians.

The convocation's participants are all respected working artists. Organizers of the forum invited painters who would broadly represent the spectrum of contemporary Native American creativity in the Southwest, from the realistic and representational to the abstract. The group was diverse in age, experience, and worldview, as well. The artists ranged from those who produce for the popular ethnic arts market to those who are influenced by global art traditions and trends and exhibit internationally. Additionally, most had other creative outlets: they were poets, printmakers, silversmiths and metalworkers, videographers, or sculptors, as well as painters. The commonalities among the group were striking and, as Whitehorse indicated, unexpected. The painters found they shared a commitment to a life in art and a deep-seated respect for their cultural roots. Daily they face the realities of their dual lives, juggling the expectations of the dominant culture with the traditional mores of their Native communities. The greatest problem, all agreed, is the stereotype of market expectations about an artist with an "Indian" label. Patronage, both past and present, presents problems not easily resolved, and the artists' reactions and solutions were as various as each individual's own experiences and creative paths.

Marcellus Medina

A look at the lives of two of the artists exemplifies this range. Largely self-taught, Zia Pueblo painter Marcellus Medina speaks eloquently about the traditions of his culture—its symbols, images, and mythology. He paints for a market interested in the traditional viewpoint and maintains that "selling culture can be done in a respectful way." Felice Lucero of San Felipe Pueblo is equally respectful of her heritage but operates from a diametrically opposed viewpoint. A highly trained artist in the Western tradition, Lucero creates decidedly contemporary work grounded in Euro-American influences. "My work has not gone the Native route," she acknowledges. Nonetheless, the spirit of Lucero's art is as resonantly traditional as Medina's. Because her work is less accessible to the general viewer and she does not depend on it for her livelihood, Lucero explores a personal creative vision that is inextricably intertwined with her cultural grounding and her deep desire to serve as a vehicle for preserving traditions. "Place is important," she says, and San Felipe Pueblo—as both a physical site and a cultural tradition—is the heart and focus of her creative expression.

The strong resurgence of tribal life and the reassertion of cultural affiliation among contemporary Native Americans is a nationwide phenomenon. Many observers of Indian life say they never would have predicted it. Indeed, they expected precisely the opposite: a continual weakening of tribal ties as a result of years of U.S. government policy and programs designed to "mainstream" Indian people and extinguish all vestiges of cultural affiliation. The vitality of traditional culture was uppermost in the minds of the participants at the IARC convocation. Young and old alike, each expressed commitment to the preservation of culture, albeit with a nod to the spirit of these times.

Tied to this determination to preserve their heritage was a unanimous concern for younger generations. Through their lives and in their art, all the artists hope to perpetuate cultural values and instill a respectful appreciation for them. For Hopi-Choctaw painter Linda Lomahaftewa, this intent is manifested through an unselfish spirit of giving something back, exemplified by a lifelong commitment to arts education. A similar concern has motivated Zuni artist Alex Seotewa's life for the past thirty years; his legacy to future generations is his work to record in painstaking detail the pantheon of Zuni ceremonial figures on the walls of the pueblo's church.

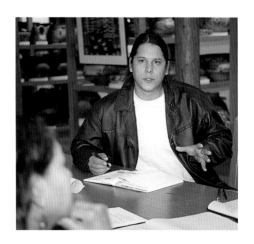

Mateo Romero

"Kandinsky talked about the inner necessity of painting and spiritual resonance. If you're not driven to do it, what is it about?"
—Mateo Romero

The convocation dealt at length with the thorny problem of cultural prohibitions and tribal proscriptions. The fact that there are sacred things that are simply not portrayed outside of the tribe is a critical issue for many Native American artists. The group held diverse opinions about artistic freedom and the Indian artist's responsibility. For some, tribal prohibitions are anachronistic and untenable in today's world; others accept an ongoing responsibility to respect them. For still others, this was not an issue of major concern, either because their creative impulses lay outside these bounds or because they have found the means to circumvent it. In abstract art, all agreed, the essence can be expressed without trespassing into sanctioned territory. This is the case for Hopi painter Jeanette Katoney, whose work is infused with a serene spirituality. As an abstract artist, Katoney has found that she can express culturally important ideas but, as she says, "not too much."

The group explored issues relating to cultural appropriation and mainstream commercialization of tribal imagery and ideas. Emmi Whitehorse asked, "Do we have the right to restrict these people? Once an image is in the mainstream, there's no control. It's basically in the public domain, and anyone can use it." She added ruefully, "There's no originality in its use. Our own people allow the images to get out there, especially young people." Michael Kabotie contributed an additional dimension to the dialogue: "I was once asked about New Agers who use Indian rituals. I think if their spiritual life is enhanced, okay. But they can't become medicine men and save souls. We can't copyright something that's universal."

This issue led to a discussion of the role of the artist as a visionary and seer, endowed with unique sensitivities and insight as well as the freedom to speak out. With wry self-mockery, Alex Seotewa told the group, "A scholar once described me as a holy man." He explained that many people travel long distances to Zuni Pueblo to see his church murals, which have had widespread exposure in the national press. "Some of these visitors are millionaires, while I can barely afford to live, but they feel I have something they haven't. Artists are looked up to." Michael Kabotie responded, "We're not religious leaders"; then, as the thought sank in, he went on, "But in a way, yes, we are, because we move things into the abstract." Kabotie concluded, "The best way to preserve things is to let them take their course. We're all involved

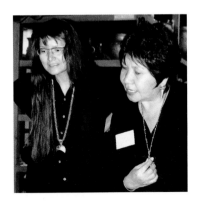

Emmi Whitehorse and
Linda Lomahaftewa

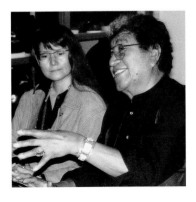

Emmi Whitehorse and Alex Seotewa

in this in our own ways, and our responsibility is to enhance what's going on."

The theme of "enhancing what's going on" is key to the role these artists play today. It expresses an adaptation of the traditional Indian integration of art with all of life to the Euro-American paradigm of "art for art's sake." In their work, in different ways, each of the convocation participants is realizing the age-old prerogative of the artist to comment on "what's going on." The cultural grounding of the ten artists was a clear and binding thread throughout the exploration of contemporary Native creativity. Although they all see art as a vital way of keeping their tribal heritage alive, each has a different approach.

Both Mateo Romero and Felice Lucero use words in their work both as visual elements and as text to increase the density and multiplicity of their expressions. This use of text in art has been a widespread trend in the latter half of the twentieth century, spawned by the conceptualist movement that arose during the turbulent mid-century civil rights struggles. Its obvious benefit is the additional layers of meaning that can be embedded in a work, thus disseminating the artist's message more widely. In the same vein, though with a more confined impact, other Indian painters make use of abstracted cultural symbols or traditional colors and ceremonial figures to speak on a deep cultural level to the initiated, while still communicating universal concepts to a larger audience.

No matter where they fit along the contemporary artistic spectrum, Native American painters today are sophisticates, culturally aware in many worlds. Still, in common with their forebears—the traditional painters whose delight in a new creative outlet gave life to the genre—they are irrefutably tied to their cultural heritage. And perhaps above all else, the lives of the artists demonstrate that Native culture and religion continue to be inextricably intertwined. Throughout the convocation an overriding sensitivity to the spiritual nature of the creative process was expressed. As Taos Pueblo artist Diane Reyna said, "A creative life is a sacred life."

Before looking more closely at the individual artists, an overview of the tradition informing their "deep remembering" is presented. An understanding of the artistic heritage lends context to these contemporary painters and their place in the continuum of the easel painting tradition among the Indians of the Southwest.

"Are we still Indians if we live outside the community?"
—Gary Yazzie

Felice Lucero and Alex Seotewa

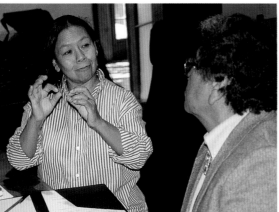

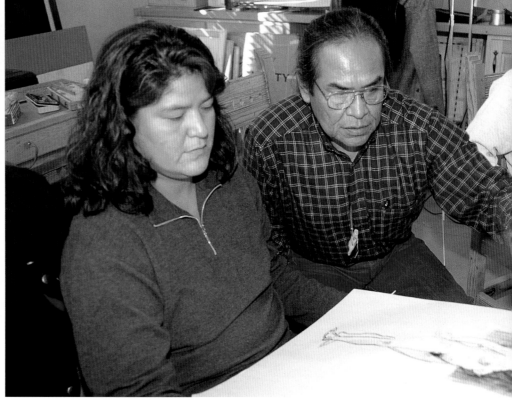

Michael Kabotie

Jeanette Katoney and Gary Yazzie

"Art is a lonely place." —Emmi Whitehorse

Diane Reyna

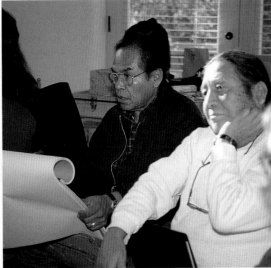

Gary Yazzie (left) and Michael Kabotie

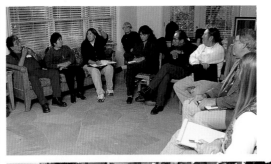

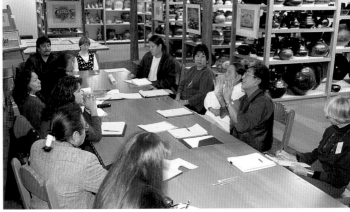

Emmi Whitehorse and
Gary Yazzie

Group discussions

"I think giving back is something instilled in Native people."
—Felice Lucero

Marcellus Medina

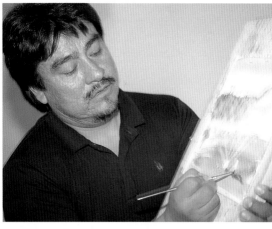

Michael Kabotie and Alex Seotewa

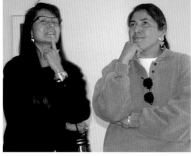

Emmi Whitehorse (left) and Diane Reyna

"I was raised to ultimately respect the decisions of elders, therefore I don't touch [subject matter related to the sacred] ...Fortunately, I don't need to, so there's no pressure."
　　　—Diane Reyna

Group session

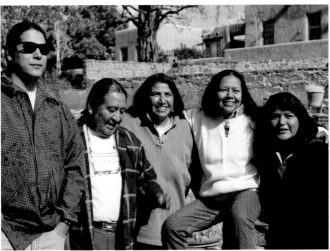

Mateo Romero, Michael Kabotie, Diane Reyna, Felice Romero, Jeanette Katoney

"Once I was involved in the market, but after my initiation I began to paint for myself. As soon as I got recognition I stopped painting because I was prostituting my art for money. I reevaluated and began other processes—got funding for the Artist Hopid project. This gave me exposure and involvement in the art world and market, but since I was doing all the business work I didn't create art. I got burned out.... Once I left, I had to recover before getting back into my art."
　　　—Michael Kabotie

The Indian Painting Tradition in the Southwest

"Art gives me a sense of belonging, of knowing who I am," said Linda Lomahaftewa at the Southwest Indian Painting Convocation at SAR. Seventy-five years earlier, referring to the Pueblo people of New Mexico, the American artist Robert Henri wrote, "They have art as a part of each one's life." Henri's observation, recorded in his 1923 book, *The Art Spirit,* illuminates the contrast between how art is perceived in the Euro-American and Native American cultures. The Western-tradition artist stands outside of society. Western art is regarded as something discrete and unique, and its making is often considered a frill, the prerogative only of those with talent or training or both. In Indian communities, art is intrinsic, intertwined with and embracing all of life. Indeed, most American Indian languages have no word for "art."

American Indian easel art in the Southwest springs from a centuries-old tradition. As a distinct art form, however, it is a phenomenon of the twentieth century. Easel painting as such did not exist in Native American societies, and the concept of a named and celebrated artist taking personal credit for his or her work was unknown. Traditional Native societies are communal, and anything created was made for the common good of the community. Only in the twentieth century did we begin to witness the transformation of an art related to the utilitarian, functional, enduring, and tribal into "art for art's sake"—a dramatic and radical shift for Native communities. This transformation reflects the social and economic changes that Indian communities have undergone over the course of the last century. Today, many Indian artists enjoy something unheard of in earlier generations: the luxury of time in which to create.

The Last Geographic Frontier

The Southwest was the last geographic frontier in the contiguous United States, and the relative isolation of its Indian and Hispanic inhabitants from the rest of the country persisted until late in the nineteenth century. The region remained fairly inaccessible until 1869, when the transcontinental railroad opened the interior Southwest to the casual visitor and entrepreneur.

Prior to the coming of the railroad, the Southwest had seen only a few significant surges of Anglo-European impact. The Spaniards, with their dreams of vast

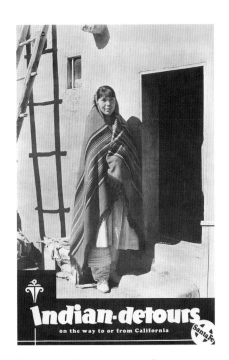

Early-twentieth-century poster for "Indian Detour" tours of the Southwest.

wealth in the fabled cities of gold, first came to what is now New Mexico in 1539. Their descendants lived alongside the indigenous inhabitants of the region for three hundred years, sharing elements of religion, culture, and lifestyle, before Anglo influence became predominant. After 1821, trade along the Santa Fe Trail had a notable impact on the region, and the California Gold Rush of 1849 brought an explosion of fortune hunters passing through on their way west. The Homestead Act of 1862, which promised every U.S. citizen the opportunity to own land in the West, brought a new influx of settlers.

But it was the railroad, making travel accessible, quick, and easy, that wrought the great and lasting change. Soon tourists, entrepreneurs, and those simply seeking a new personal frontier began flocking to the Southwest, clamoring to see its dramatic landscapes, learn about its "exotic" Indians, and exploit its resources. The rush of settlers and visitors brought radically new ways and ideas that were to have far-reaching effects on Native American life.

The Traditional Roots of Easel Painting

As Robert Henri observed, art was an intrinsic part of everyday life in traditional Indian communities. Every activity—farming, herding, cooking, weaving, pottery making—was inextricably tied to the group. Collectively, the family, the clan, or the tribe benefited from the individual's culturally imbued sense of harmony, beauty, and balance.

Indians of the Southwest had painted for centuries, using indigenous equivalents of artists' tools such as palettes, brushes, and paints. In earlier times, paints and dyes were made from minerals and organic natural materials including plants, colored clays, and animal products. In some tribal cultures, colors have symbolic overtones and religious significance and therefore constitute a visual language of their own. Brushes and quills were manufactured from plant materials like the sharp-pointed yucca blade, as well as from animal bones and hair.

The humble and utilitarian objects of everyday life were created with a beauty of form and harmony of design. Pottery, baskets, textiles, and clothing were frequently decorated with traditional motifs such as geometric patterns, stylized plant

Sand Painters, by Harrison Begay, Navajo,
ca. 1968. Watercolor, 14" x 14 1/8".

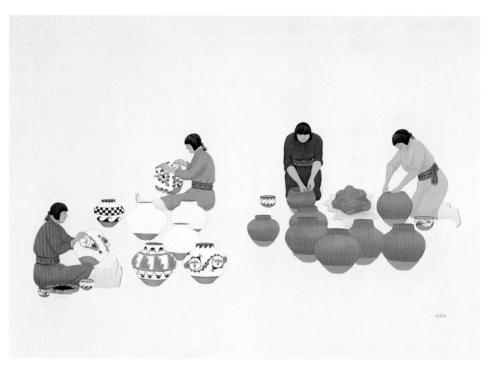

Sketching on the Wall, by Robert Chee
(1938–72), Navajo, ca. 1960s.
Watercolor, 16" x 20". SAR 1969-31.
Reflecting on the rock art imagery left by
Pueblo ancestors, Felice Lucero said, "They
have no setting, like floating in space.
They have an 'aroundness'; there is no place
to focus." In Robert Chee's humorous
rendition, a contemporary rock artist
adds his sketches to an ancient mural.

Making Pottery, by Velino Shije Herrera
(Ma-Pe-Wi, 1902–73), Zia Pueblo, ca. 1928–30.
Gouache on Whatman board, 14 1/2" x 22".
IAF P2.
Herrera was one of three young Pueblo men
employed in the 1920s by Edgar Lee Hewett at
the School of American Research and encour-
aged to explore painting on paper. Here, Herrera
depicts the age-old process of pottery manufac-
ture at Zia Pueblo. The women on the right
are building hand-coiled clay vessels; their
counterparts on the left are painting traditional Zia
designs over the unfired red pottery, which has
been covered with a white clay slip.

Hewett also commissioned Herrera to paint
the Zia ceremonial cycle. The Pueblo leaders were
so angered by this recording of their religious life
that Herrera was ostracized from the village. After
living at several other pueblos, Herrera eventually
settled in Santa Fe, where he established a studio.
A prolific painter, he was among the first Native
artists to devote himself to making art full-time.

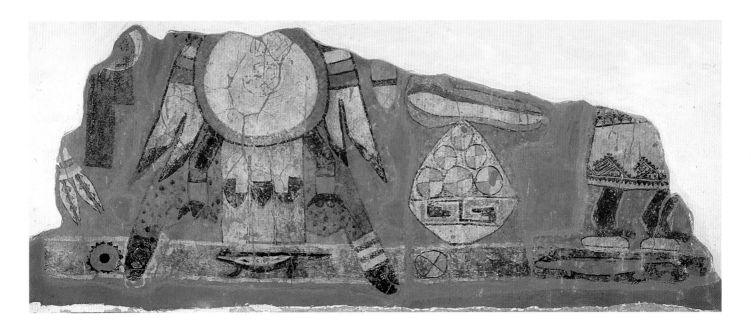

A kiva mural from the ancient Hopi village of Awatovi.

Kiva murals in the Southwest date back to about A.D. 900. The earliest images were simple, almost abstract geometrics; later paintings were more representational, depicting kachinas, human figures, ceremonial paraphernalia, and a wide assortment of plants and animals. As Mateo Romero noted during the gathering, "kiva murals are a concise language of Native American people."

and animal forms, and other cultural symbols derived from the natural world and relevant to the sacred life of ceremony and religion. Native Americans have also traditionally painted their bodies for ceremonial purposes. Wooden altars, the headdresses known as *tablitas,* rattles, dance wands, and kachina dolls are always prayerfully created and decorated in accordance with tribal prescription. Animal hides and woven fabrics might be painted and made into clothing, ornaments, shields, and other ceremonial regalia. Intricate designs created with sand and ground minerals and plant products have long been used for religious purposes by many tribes; today, the Navajos are the most sophisticated practitioners of the ephemeral sand-painting form.

Rock art is one of the most ubiquitous precursors of easel painting among Southwestern peoples. Found on the walls of canyons and caves throughout the Southwest, it too has been practiced for centuries. Pictographs are images pecked or carved into the rock surface, and petroglyphs are drawings on the rock. In all likelihood the images were made for informational and ceremonial reasons; certainly no attention seems to have been paid to studied elements of composition and design. Today, rock art serves as a singularly enduring and rich compendium of cultural motifs, a virtual design dictionary of the shapes and patterns used by Southwestern cultures throughout the ages.

The murals that decorate the walls of kivas, the underground ceremonial chambers of Pueblo villages, have been another important influence on the pictorial

tradition. These intricate and colorful paintings contain a rich panoply of ceremonial figures, scenes, symbols, and designs that have been employed since long before the time of European contact.

In light of the long history of the Southwestern Indian painting tradition, a case can be made that applying brush to canvas or paper was merely the next step in a continuum. Technically, there is some truth to this. But painting on a flat surface has taken on a radically different meaning and use, conditioned by the changing needs of the local people and the realignment of social structures.

The Role and Influence of Anglo Patrons

"I wonder what part in an encyclopedia of American art the decorative and significant work of the Indian will play...there has been going on for centuries a very remarkable art expression right here—*pure art, not imitation*" (emphasis added). Thus wrote Robert Henri in Santa Fe in 1923, amazed by the sophistication and depth of the aesthetic tradition he found in the Southwest. Painter, educator, and insightful observer of American culture, Henri was but one of many highly cultivated Anglo intellectuals, writers, educators, aesthetes, visual artists, and scientists who were discovering the landscapes and cultures of the Southwest during the early years of the twentieth century. The role they played in encouraging the easel painting tradition among the region's Indian inhabitants is the next chapter of this story.

Although thoughtful individuals today may lament the influence that the dominant culture has had on Native Americans, the largely altruistic intentions of these influential Anglos early in the century cannot be dismissed. Strongly attracted to Indian cultures, both aesthetically and metaphysically, the newcomers also carried the banner for a new era of social reform that was sweeping the country. One manifestation of the movement was a profound reaction against the prevailing U.S. government policy designed to Americanize the "red savage" and erase every vestige of tribal culture.

Henri's delight in the refined creativity of the Southwestern Indian thus reflected the spirit of the times. That Santa Fe became the regional center of this spirit is easy to understand. The city was already well into its third century as a thriving

community of mixed European, Mexican, and Anglo-American heritage, literally built upon the foundations of pre-existing Native American settlements. Santa Fe projected an appealing aura of sophisticated tradition, blended cultures, and deep historical roots, coupled with the beauty and tranquility of its high desert setting. The new Santa Feans shared a sort of cultural malaise about the course of Western civilization in the twentieth century and saw much to value in local Indian cultures. They particularly respected the beauty of the Native American worldview and the simplicity of a lifestyle that emphasized living in harmony with nature.

It must be noted that this was a group of strong personalities, intelligent, creative, and talented—and, for the most part, wealthy. With both influence in high places and the will to act upon their convictions, they sought to preserve and promote cultures and lifeways they had every reason to believe were quickly passing from the scene. Many were ardent activists for Indian rights, both locally and nationally. Additionally, they were sympathetic to a spirit of revolt abroad in many parts of the world: a rebellion against mass production, mechanization, and industrialization, and an appeal for a return to handmade and handcrafted goods.

Santa Fe's Euro-American arts community gave an extraordinary impetus to the emerging Indian easel painting movement. These individuals perceived Native visual art as an American art genre, not simply a primitive curiosity, and their efforts to promote it were guided accordingly. Well connected to the national art scene, they took every opportunity to help young Indian painters find exhibition venues. They avidly collected their paintings and served in many cases as mentors and friends to the young artists, helping them navigate the unfamiliar ways and expectations of Anglo-American society.

The Scientists' Formative Role

The early years of the twentieth century also saw feverish archaeological investigation across the Southwest by men and women who were probing the region's human prehistory and pioneering the science of American archaeology. Like the Santa Fe arts community, the scientists were fascinated by the Indians they met and often employed

Crescencio Martinez and his wife, Maximiliana, ca. 1915.
Maximiliana, a potter, was the older sister of the renowned San Ildefonso artist Maria Martinez. For many years, Crescencio had decorated Maximiliana's pottery, so his transition to drawing on paper was relatively effortless.

on the archaeological sites. They also recognized that the lives of these contemporary Native Americans held valuable clues to their ancestral past. As a consequence, efforts were made throughout the Southwest to encourage Indian people to record the imagery related to their ceremonial life. Most of the instigators were members of archaeological teams, primarily interested in the cultural information the drawings revealed. As will be seen, a handful of these early Native "informants" would go on to become the well-known founders of the Native American easel art tradition.

The criticisms that are directed today at the cultural intelligentsia of the period apply equally well to the archaeologists. Their zeal and their invasive actions in the name of science were occasioned by the belief that they were in a race against time. Caught up in the contemporary wisdom that Indians were a vanishing people who would soon become extinct, the scientists sometimes lost sight of the Indians as self-respecting individuals of dignity and intelligence.

The prototypical effort to record Indian images on paper was made by the archaeologist and ethnologist Jesse Walter Fewkes, who worked at the Hopi mesas in Arizona in the 1890s. Providing paper, watercolor paints, and other drawing supplies, Fewkes encouraged several Hopis, most prominently two men, Homovi and Kutcahonauu, to record ceremonies and dance figures. Their drawings comprise an extraordinary compendium of Hopi ceremonial life, accurately detailing the ethnographic information Fewkes was after.

For the most part, the archaeologists had no explicit interest in artistic style or creativity as such. Edgar Lee Hewett, however, was a notable exception, and his recognition of Native American creativity was to have far-reaching effects. Beginning in 1909, Hewett, director of the Museum of New Mexico and the School of American Archaeology (now the School of American Research), conducted archaeological studies on San Ildefonso Pueblo lands northwest of Santa Fe. Quite by chance, Hewett came upon Crescencio Martinez (Ta'e, 1879–1918), a pottery decorator, drawing traditional Pueblo figures such as Buffalo dancers on the ends of cardboard boxes. Sensing the artistry of Martinez's efforts, Hewett gave him paper and other art materials and encouraged him to continue this pastime.

Mucaias Taka (Buffalo Youth, left) and Mucaias Mana (Buffalo Maiden, right). Early Hopi paintings done for J. W. Fewkes. Watercolor on paper, size unknown. In the 1890s, Jesse Walter Fewkes asked some Hopi men to make drawings of Hopi ceremonial life. He published several hundred of the technically naive but elegant and detailed drawings in the 1903 *Annual Report of the Bureau of American Ethnology*. These were reprinted in Fewkes's *Hopi Katcinas* in 1991.

Later, Hewett commissioned Martinez to make a series of paintings of Pueblo ceremonies and dancers. Painted in 1917 and 1918 (the year of Martinez's untimely death), these are landmark pieces in the short history of contemporary Native American easel art, formally denoting the start of the new tradition and the emergence of the named individual Indian artist. The sophistication and elegance of Martinez's paintings inspired Hewett to encourage other Indian artists, as well.

Dorothy Dunn, 1937.

The Santa Fe Indian School,
Dorothy Dunn, and the Studio

In the last decades of the nineteenth century and the first decades of the twentieth, U.S. Bureau of Indian Affairs (BIA) schools sprouted up across the Southwest. Only a few truly humane educators could be found within this severe system, which was dominated by rigid curricula and a harsh daily regimen reflecting the government's Indian policy. Two such outstanding and influential individuals were Santa Fe Indian School superintendent John DeHuff and his wife, Elizabeth.

Like Hewett, Elizabeth DeHuff perceived the innate creativity of some of the Indian students. Believing that a relaxing and creative period would be a welcome respite during their rigorous school day, DeHuff started an after-school painting and drawing class in her home. Among the participants were Fred Kabotie, a young Hopi, and Velino Shije Herrera, of Zia Pueblo, both of whom would later become noted painters.

In 1919 the students painting at the DeHuffs' home took part in a special exhibition at Santa Fe's new Museum of Fine Arts, probably the earliest public event to spotlight the nascent Indian easel art tradition. In subsequent years, some members of the city's artistic community would arrange or facilitate similar exhibitions, both locally and across the nation, bringing the work of the young Indian artists to the attention of a broad audience.

Into this scene came an Anglo woman, Dorothy Dunn, whose name is more closely associated with the tradition of Native American easel painting in the Southwest than any other. Although the Indian easel art tradition had already received a good deal of encouragement, it was Dunn's sustained efforts that focused the myriad and disparate endeavors.

Dunn had taught at several government Indian schools in New Mexico during the 1920s. After returning to Chicago to earn a fine arts degree from the Art Institute, she returned to the Southwest with the goal of teaching art at an Indian school. Her previous experiences in New Mexico had made her aware of the talents of

Indian children, and she was determined that they should have opportunities to express their creativity. The BIA schools had no arts education programs, and Dunn became a fifth-grade teacher at the Santa Fe Indian School in 1932. Shortly thereafter, with the blessing of the school's superintendent, Dunn set up an after-school art project that she called the Studio.

The success of the Studio was immediate. Students were enthusiastic about the project, and forty of them participated during that first semester. The young artists were from most of the Southwestern tribes—the Rio Grande and northern New Mexico Pueblo villages were well represented, and there were Hopi, Navajo, Apache, and several Plains students, as well. Dunn convinced her supervisors at the school that the program had merit, and the next year a formal program of art and design classes was added to the curriculum. Dunn was named to the newly created post of Teacher of Fine and Applied Arts. Unquestionably, the nation's mood for social justice and reform in the 1930s, as well as the enlightened policies of John Collier, the Commissioner of Indian Affairs, had contributed to the success of Dunn's cause.

From the outset, the arts education program at the Santa Fe Indian School flourished. Student output was prolific and showed great promise, and the enthusiasm and support of the local arts community was a major factor in its success beyond the school's walls. Interested Santa Feans continued to open doors in support of the fledgling program and its unknown artists.

Over the years, Dunn has been criticized for her efforts. It has been said that she molded Native traditions and commercialized Native talent, robbing the young artists of their spontaneous creativity. In *Modern by Tradition,* their study of the Dunn legacy, Bruce Bernstein and Jackson Rushing quote the Chiricahua Apache artist Allan Houser (1915–94) as saying, "She trained us all the same way.... Her style lacked originality and creativity."

Dunn's response to her critics was always firm. Her task, she maintained, was simply to focus the efforts of naturally talented individuals. She wanted to expose them to world art traditions and to provide the time, place, materials, and encouragement for their individual pursuit and exploration of an art tradition she saw as unique and importantly American. Considering the concurrent shift in public sentiment toward

Pablita Velarde painting a mural for the
Public Works of Art Project, 1934.
Pablita Velarde of Santa Clara Pueblo
(born 1918) was one of Dunn's outstanding
students. In a 1996 interview with Estella
Loretto, Velarde said, "I was greatly
influenced by the gentle encouragement
and patience of my teacher, Dorothy Dunn.
Dorothy would encourage me to think
about my family back in the pueblo and
our lifestyle. She always encouraged us to
paint what we knew best."

the treatment of Native Americans, Dunn's instincts were at the forefront of the per-
vading spirit of social reform. Her objective was to provide an outlet for the creativity
of her young protégés by rekindling their tribal memory and cultural ties, albeit in the
"new" format of painting and drawing with line and color on a flat surface.

In an article Dunn wrote for the magazine *El Palacio* in 1977, Fred Kabotie
reinforced and confirmed the value of Dunn's work. From his seasoned perspective as
an arts educator, world-renowned artist, and winner of a Guggenheim Fellowship, he
said, "Basically the old way of painting is the beginning for the oncoming young artist
who has not lost contact with the home background, and out of this something differ-
ent evolves and opens the way to develop into a new style."

One consequence of Dunn's efforts is that the painting style associated with
the Studio is still called "the Dunn style." Her emphatic exhortation to her students
to preserve their individuality and paint from their unique cultural perspective was

Navajo Woman with Yarn, by
Andy Tsinajinnie (1918–2000), Navajo,
1935. Watercolor, 12" x 8 1/2". IAF P206,
gift of Kenneth Chapman.

Tsinajinnie's simple, eloquent composition, painted while he was Dorothy Dunn's student, effectively represents the essence of the "traditional" style associated with the Studio. His subject matter is drawn from childhood memories, and the execution is typical of the Studio's "less-is-more" style. The boldness and strength that characterize Tsinajinnie's finest work are clearly foreshadowed in this early student piece.

Five Kiowa Dancers, by Stephen Mopope
(1898–1974), Kiowa, n.d. Watercolor,
8 3/8" x 12 1/2". IAF P169.

In the 1920s Susan Peters, a field matron for the U.S. Indian Service in Anadarko, Oklahoma, started an art club for young Kiowa students. Later in the decade, these same students were enrolled in a special arts program at the University of Oklahoma. Stephen Mopope was a member of the group, which came to be known as the Kiowa Five and was surrounded by controversy about the extent of outside influences on their work. Certainly this painting indicates some awareness of the exuberant design principles of the contemporaneous Art Deco movement.

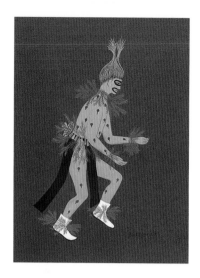

Untitled clown, by Geronima Cruz Montoya (P'otsúnú), San Juan Pueblo, 1969. Watercolor, 13 3/4" x 9 3/4". IAF P302.

Montoya entered the Santa Fe Indian School in 1927, when she was a fifth-grader, and later participated in Dorothy Dunn's newly established Studio, where she exhibited a natural talent and blossomed under her teacher's encouragement. In 1935 Dunn invited Montoya to assist her in the Studio. When Dunn retired in 1937, Montoya, though only recently graduated from high school, was appointed her successor.

key. Through the new format of easel art, she believed that they could revitalize their personal cultural memory and concurrently aid the enhancement and preservation of their cultures. But change is inevitable, and even in this heretofore remote region of America the twentieth century was rushing in. It is interesting to speculate whether a different approach would have produced an art more palatable to Dunn's critics. For all the disapproval that can be directed toward her efforts, she was truly a cultural pioneer, and her work reflected the prevailing social climate of the nation. Efforts similar to hers were under way elsewhere, most notably among the Kiowas in Oklahoma.

Dunn remained with the Studio for only five years. She was succeeded by several of her students, of whom the most prominent was Geronima Cruz Montoya, born 1915 (P'otsúnú), a San Juan Pueblo artist who successfully led the program until 1962, when it was replaced by the Institute of American Indian Art.

It is in part a consequence of the success of the Studio and Dunn's work there that even today the general public holds a fairly fixed image of Southwestern Indian painting. Although members of the Santa Fe cultural community made significant efforts to "mainstream" Indian easel art, placing it in the New York Society of Independent Artists' Annual Show and at the Museum of Modern Art, the fresh, naive honesty and exotic subject matter gave the paintings an appealing otherness that the public admired and collectors clamored for. Paradoxically, then, the die was cast. The Dunn style became the accepted "look" of Native easel art. A mutual dependency between artist and patron resulted, and a stagnation and virtual creative strangulation of the genre would occur several decades later. Today, the stereotype remains a serious impediment for some contemporary Native artists; for others, it provides a creative springboard.

The Studio, traditional, or Dunn style has its roots in Indian decorative arts and such historical precursors as kiva murals and rock art. It is painting that pleases the eye with its grace, harmony, and balance. Flat patterns, exquisite attention to detail, and rhythmic repetition are salient characteristics. Settings are minimal; only occasionally do flora, fauna, or the placement of clouds and birds indicate the ground line, horizon, or sky.

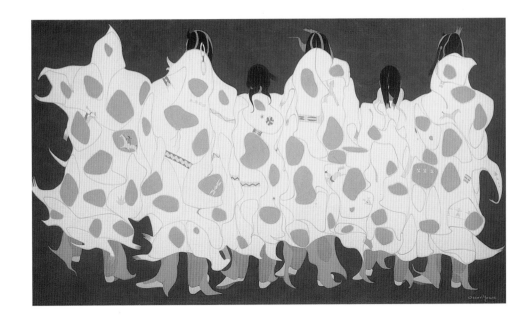

Dance of the Mourners, by Oscar Howe (1915–83), Yanktonai-Sioux, ca. 1960. Casein on paper, 14" x 25".

This work by the celebrated Sioux painter Oscar Howe, another Dorothy Dunn student, is representative of the dilemma faced by many Indian artists. Howe developed a highly personal style based on the dynamic abstraction of traditional themes, but even as late as 1958, his work was rejected by the annual Indian art exhibit at the Philbrook Art Center in Tulsa. The exhibition had no category for a piece that was not "Indian"—that is, done in a recognizable "traditional" style.

The Studio style is essentially storytelling art, conveying information about a way of life in a lyrically simple fashion. Its most popular subjects are ceremonial figures and dances, genre scenes of home and village life, pastoral scenes, and whimsical patterned elaborations on traditional designs. There is distinctive tribal variation, consciously fostered by Dunn's insistence that her students create from their particular cultural perspective.

Pioneer Pueblo Painters

The first Indians in the Southwest to practice painting as a unique and separate form defined the subject matter for their successors. Not insignificantly, they were some of the first Indian artists to sign their work. San Ildefonso Pueblo produced the first commercially successful Southwestern Indian painters, and other early Rio Grande and northern New Mexico Pueblo artists emulated their style. Theirs is a relatively static art, characterized by lines of dancers, quiet domestic scenes, or inventive elaborations on traditional design motifs. In contrast, the traditionalist Hopi painters from northern Arizona exhibit a greater sophistication. Figures are rendered with greater modeling, shading, and individuality. The early Hopi artists attempted more complex spatial effects utilizing perspective and shading. J. J. Brody gives a lively account of the artwork in *Pueblo Indian Painting: Tradition and Modernism in New Mexico, 1900–1930.*

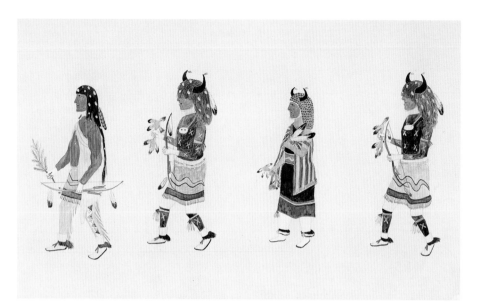

Buffalo Dancers, by Crescencio Martinez, San Ildefonso Pueblo, 1918. Pencil and watercolor on paper, 14 3/4" x 23". IAF P19.

Martinez's great talent was for the careful rendering of detail in paintings of ceremonial dance figures. His attempt to convey the rhythm of the dance lends a spirited human dimension to this otherwise static composition.

The Buffalo Dance at San Ildefonso Pueblo, date unknown.

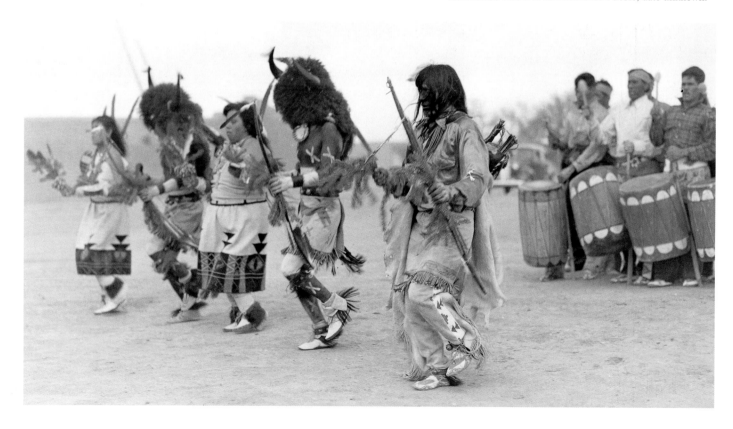

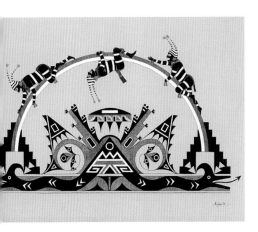

Koshare on Rainbow, by Awa Tsireh (Alfonso Roybal), San Ildefonso Pueblo, ca. 1925–30. Ink on linen textured paper, 11 1/2" x 8". IAF 1978.1.318.

Awa Tsireh pioneered in the abstraction of traditional design motifs. His elegantly stylized works appealed strongly to the modernist sensibilities of many Santa Fe patrons of the time. The juxtaposition of embellished design and realistically rendered clowns, seen here, is a precursor of the style that today informs the work of many Native abstractionists.

Although numerous isolated examples predate him, Crescencio Martinez of San Ildefonso is generally considered the first serious Indian easel painter in the Southwest. Encouraged by Hewett to record on paper images of ceremonial figures and dances, he provided the impetus for an entirely new genre of expression among Native people. His spontaneously rendered images set a standard, in terms of both content and form, that spread to other Rio Grande Pueblo people who followed his lead during the century's first decades.

As an artist, Martinez was unconcerned with setting and environment. Initially the focus, indeed the purpose, of his art was to provide information, and this he had in abundance. Confirming Hewett's premonition about his response to the creative and compositional challenges of the flat piece of paper, however, Martinez soon went beyond the role of informant-illustrator and quickly adapted to the use of commercial paints. His facility with intricate pattern and detail was no doubt an outgrowth of his work as a pottery decorator. Naive as the artist's technique may be, the viewer delights in his attempts to capture the human figure in motion and is rewarded by insights into a colorful culture, not to mention the birth throes of a new art form.

Awa Tsireh (1898–1955), also known as Alfonso Roybal, was another of the pioneering San Ildefonso painters and one of Martinez's prominent successors. A growing sophistication and maturity are apparent in this artist's prolific output. Hewett, inspired by his success with Crescencio Martinez, hired Awa Tsireh and several other young Pueblo men to work at the School of American Research. Their daily schedule included blocks of free time, which they were encouraged to spend developing their mastery of the new style of art. Awa Tsireh took full advantage of this time for experimenting with the easel art medium and played a formative role in its stylistic development. In addition to ceremonial dance figures and scenes, he explored a variety of subject matter and pioneered several new formats, including one that featured elaborate reconfigurations of abstract designs. Probably influenced by the beautiful traditional motifs found in Pueblo embroidery and pottery decorations and by prehistoric kiva mural imagery, his proclivity for pattern and design blossomed.

Awa Tsireh was the first to paint scenes of Pueblo community and home life. His cameos of Pueblo domesticity, which are instructional and important to the

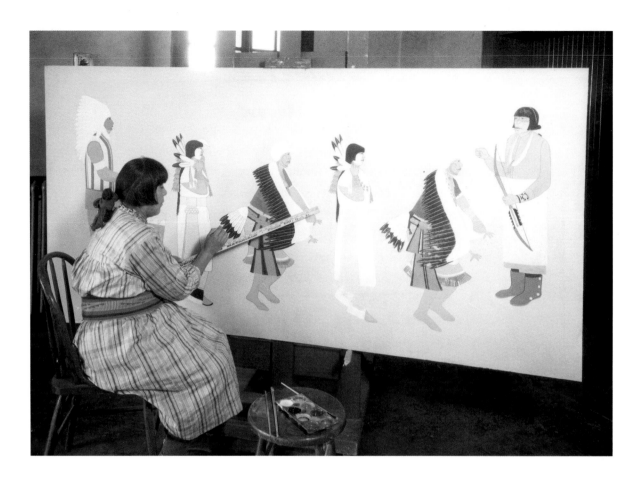

Tonita Peña painting the Eagle Dance, ca. 1935.

Santa Fe Indian School students painted cooperative murals on the walls of their classrooms and on large canvas panels. Popular with the public, the large-scale paintings were exhibited in several venues across the nation.

ethnographic record as well, suggest an increasing sophistication as the artist grappled with anatomical structure and evolved in his understanding of perspective. Awa Tsireh's paintings were included in many of the early exhibitions, both in Santa Fe and beyond, earning him acclaim at an early age.

Few Indian women painted in the early years, but those who did were markedly successful and exhibited an admirable spirit of independence. It took courage and strong artistic commitment to pursue a creative course completely outside the traditional role prescribed for Pueblo women. Tonita Peña (Quah-Ah, 1895–1949) was born at San Ildefonso Pueblo and moved to Cochiti as a child. In style and subject matter, her work resembles that of the early San Ildefonso artists. Peña's life was not an easy one, but through it all she persisted in her painting. She was widely appreciated by Santa Fe arts patrons and today is acclaimed as an important pioneer of the easel painting genre.

Fred Kabotie (1900–1986), whose long career as an artist and cultural

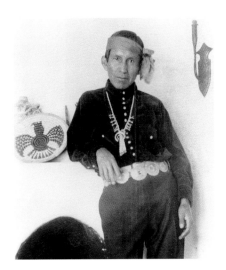

Fred Kabotie in the living room of his mentor and friend Elizabeth DeHuff, Santa Fe, ca. 1920.
Kabotie and his friends were always welcome visitors in the DeHuff home just off Canyon Road.

ambassador for the Hopi people brought him world renown, was perhaps the most gifted of the early group of young painters. Like Awa Tsireh and Velino Shije Herrera, he worked for Hewett and flourished creatively in the time provided to experiment with the "new" technique of painting on paper. Kabotie was brought to the Santa Fe Indian School at a young age and found the regimented life there a far cry from the nurturing environment of his Hopi homeland. Elizabeth DeHuff's after-school art program provided a relaxed setting and was his introduction to easel painting; DeHuff's friendship was to have a lasting impact on Kabotie's life. Years later, in a conversation that Tryntje Van Ness Seymour recorded in *When the Rainbow Touches Down,* Kabotie reminisced, "Naturally I painted what I missed...what was dear to me as a Hopi life. I painted katsinas." Like Crescencio Martinez at San Ildefonso, Kabotie set a standard for Hopi art, in terms of subject matter and style, that endured for years.

After his early bouts of homesickness, Fred Kabotie came to enjoy his years in Santa Fe. Numerous opportunities opened up for him as his circle of friends expanded and his talents blossomed. Finally, in 1930, he returned to his home at Shungopavi on Second Mesa, and a year later he married. Kabotie underwent the initiation ceremonies of his tribe and devoted the rest of his long, productive life to the Hopi way.

This most traditional of Hopi men nonetheless kept in touch with many of the influential Anglo patrons he had met in Santa Fe, and they continued to be helpful in bringing opportunities his way. Over the years Kabotie served as a cultural ambassador for his people, traveling internationally to participate in exhibitions and programs that would benefit tribal projects. His constant concern was the survival of the Hopi way in the twentieth century. For many years he taught art at Oraibi High School, strongly influencing a younger generation of students to continue creating from the wealth of their traditional culture. Today he is recognized as the dean of Hopi art and one of the most talented exponents of the traditional Hopi style. His mastery of draftsmanship and spatial modeling and his painterly facility with color set a high standard. Ever respectful of tribal proscriptions against the representation of sacred images, Kabotie otherwise represented every aspect of Hopi life in his work.

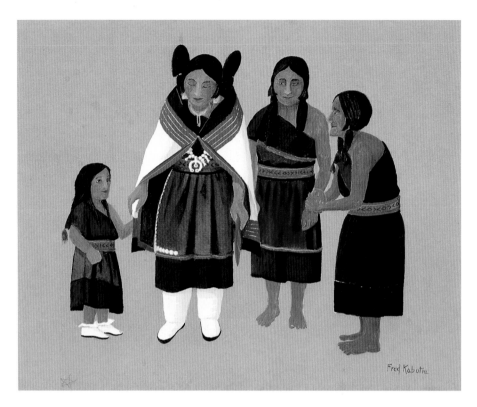

<
Hopi Girls and Women, by Fred Kabotie,
Hopi, ca. 1924–30. Gouache on paper,
11" x 12 1/2". IARC P110.
Kabotie was the first Indian painter
to address the individuality of his
subjects. In this remarkable scene, four
generations of women are portrayed. The
beautiful young woman, resplendent in
her maiden shawl and butterfly-whorl
hairdo, holds center stage both physically
and metaphorically.

*Mother and Daughter Hopi
(Moki)Indians.*
This penny postcard showcases two
generations of Hopi womanhood in an
"exotic" scene that made for a popular
souvenir of the Southwest.

Three Sand Painting Figures, by Apie Begay, Navajo, 1902. Wax pencils and pencil drawing, 6 1/2" x 11". IAF P64, gift of Kenneth Chapman.
When Kenneth Chapman visited the western Navajo Reservation around the turn of the century, he heard stories of a fellow "who did nothing. He is an artist." The man was Apie Begay. Chapman tracked him down and found him sitting on the floor of his hogan, drawing sand-painting images on scraps of paper. Chapman obtained crayons for him, and Begay delighted in their creative possibilities—as these drawings show.

The First Navajo Painters

For centuries the traditionally nomadic Navajos have had a special knack for adapting and assimilating the lifeways and cultures of other peoples they encounter. Not surprisingly, therefore, the earliest Navajo easel artists quickly excelled in the new format, and in many ways their work was the most dynamic, presenting the greatest variety in style, composition, and subject matter. Historical accounts record isolated instances of Navajo painters, including Kenneth Chapman's discovery of Apie Begay, but it was at the Studio that young Navajo students first defined a distinctive Navajo painting style by depicting the landscapes of their homeland, scenes of pastoral activities and traditional family life, and their rich heritage of myth and ceremony.

In style, early traditional Navajo paintings are typical of the Studio genre. The artists were hugely successful in creating lighthearted pictures richly evocative of their colorful homeland and family-centered lives. But even these nature-loving painters kept setting and landscape to a minimum. The horizon may be denoted by the profile of a mountain, butte, or mesa, while the planes of the foreground are delineated by stylized plant motifs and occasional wild or domestic creatures. This is narrative art at its most colorful, but traditional Navajo easel art is also one of consummate design. Like Navajo weaving, its essence is symmetry and balance, beauty of form, and harmony of color.

Many of the traditional Navajo artists were prolific, and their subject matter was popular with the public. Encouraged by Indian traders in the Four Corners states (Arizona, Utah, Colorado, and New Mexico), several have been painting for more than sixty years. Harrison Begay (born 1917) is surely one of the best known, and one of very few traditional Indian painters to consistently make a livelihood from art. That Begay could do this is thanks in large part to the lifelong encouragement of several Indian traders, including the anthropologist Clay Lockett, who employed him in his Tucson Indian arts and crafts shop for many years.

The story of Lockett's long interest in Begay is representative of countless other instances of mutually beneficial relationships between Indian artists and traders or benefactors and illustrates another aspect of the story of influential white patrons who furthered the careers of the earliest Indian painters. In the case of the traders, the

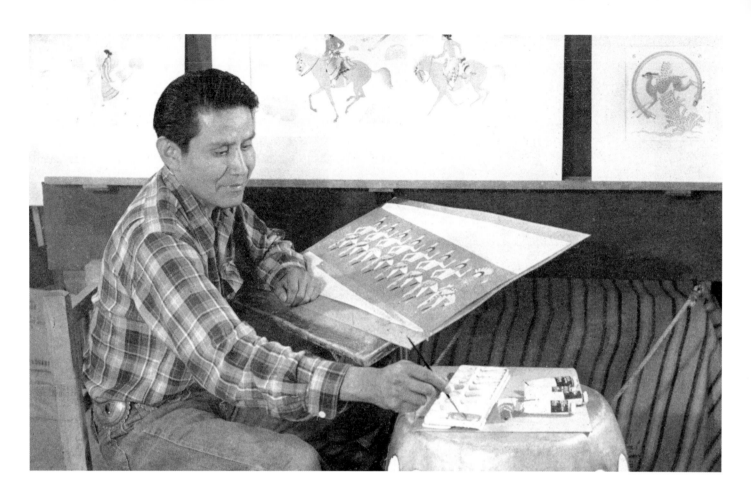

Harrison Begay, ca. 1950.
After World War II, many Indian traders and curio dealers employed Native artists to work in their shops. Begay frequently worked as an "artist in residence," providing local color, introducing shop visitors to the Indian painting tradition, and occasionally selling a painting as well.

artist's commercial success was, of course, key to the relationship. The traders' role in perpetuating a style that the public enjoyed ensured that today the traditional painting style remains *the* Indian easel style in the minds of the most people.

As a child, Begay was taken from his home on the Navajo Reservation and sent to a U.S. government boarding school. Consequently, although his love for the pastoral reservation life was deeply ingrained, he knew very little about the traditions of his people. In an effort to expand Begay's knowledge of his Navajo heritage and provide colorful subject matter for his art, Lockett and his friend, the artist Don Perceval, gave him a volume called *Navaho Legends,* compiled in 1897 by Washington Matthews. Begay was fascinated by the rich legacy of ceremony and myth recounted in the book, and a whole new world opened up for him.

All of the early Navajo traditionalists evolved along similar lines, painting scenes that evoked their love of the colorful lands of their home and the traditions of

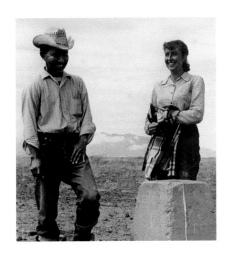

Sallie Wagner and a teenaged Beatien Yazz at Four Corners Monument, ca. 1948.

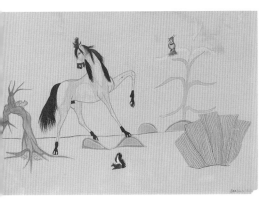

Blue Horse, by Beatien Yazz, Navajo, ca. 1942. Watercolor, 12" x 17 3/4". SAR 1983-12-78.

Spin a Silver Dollar, by Alberta Hannum, fictionally recounts the story of Jimmy Toddy (also known as Beatien Yazz, or "Little No-Shirt") and the Lippincotts at the Wide Ruins trading post. This charming account of a Navajo child's life in the Southwest of the 1940s was illustrated by Jimmy Toddy. *The Blue Horse,* used on the book's dust jacket, was painted when he was about fourteen. Thanks to the book's wide popularity, it has been said that by the age of sixteen Jimmy Toddy was the most famous Indian in the nation.

their tribe. Here, however, the similarity ends, for among the most notable of this early group there is evidence of far greater innovation and distinction in style than among the Pueblo painters.

Beatien Yazz (born 1918), also called Jimmy Toddy, has been painting since he was a small child living near the Wide Ruins Trading Post in western New Mexico. Like Begay, the lifelong success he has had in art owes much to the support and interest of an Anglo patron, Sallie (Lippincott) Wagner, who, with her husband at the time, owned the trading post at Wide Ruins. One day Wagner discovered Jimmy Toddy, the handyman's son, doodling on scraps of paper he had pulled out of the trash. Happy to encourage his creative bent, she bought him some art materials on her next trip to town. In the years since then, Wagner has steadfastly encouraged Yazz and now takes an interest in his family, many of whom are also painters.

Throughout his long, productive life, Yazz has exhibited tremendous versatility in his assimilation of styles and subject matter. The IARC's collection of Yazz paintings, the gift of Sallie Wagner, is definitive, tracing the painter's career from his earliest childhood drawings through his experimentation with abstraction in the 1960s, and beyond. At its best, Yazz's work is consummately poetic, a paean to traditional Navajo life in the first half of the twentieth century.

Another representative and noteworthy Navajo student of the Studio was Narciso Abeyta (Ha-So-Deh, 1918–98). Almost from the outset, he demonstrated a unique individualism, painting in a style characterized by expressionistically bold, broadly brushed strokes. In contrast with his contemporaries' loving attention to detail and gentle tribute to the high desert lifestyle, Abeyta's vision is striking and strong. His palette is bright and deeply resonant, and he often outlines broad planes of color in a dark tone, lending his composition a shimmering effect like that of stained glass.

Hiatus and Transition: The War and Postwar Years

A multitude of talented Indian painters emerged during the 1930s, when the success of the Studio project inspired the U.S. government to institute fine arts programs at other, larger Indian schools, such as those in Albuquerque and Phoenix. But

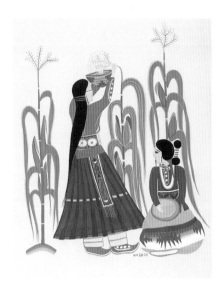

Shaking Pollen from Corn, by Narcisco Abeyta (Ha-So-Deh), Navajo, ca. 1938–40. Gouache on paper, 14" x 12". IAF P312.
Abeyta frequently depicted scenes from Navajo mythology and legend, but even in quiet domestic scenes such as this his paintings are characterized by a distinctive dynamism and fluidity. Abeyta's work exemplifies the pronounced individualism displayed by the early Navajo painters.

international turmoil and the entry of the U.S. into World War II severely impacted even the Native communities of the Southwest and their emerging easel art tradition.

The World War II years were truly transformative for Native Americans. Most of the early traditional painters enlisted in the war effort. Following the war, the tempo of life changed across America, and nowhere more so than in the interior Southwest. Many young Indian men and women had traveled internationally while serving in the armed forces, and they returned home with vastly expanded horizons and a new understanding of opportunities for personal development. The GI Bill made higher education a viable possibility that many took advantage of.

For some, readjustment was a great struggle, and shattered lives had to be rebuilt in the face of a vastly changed world. Exploding technology also brought huge changes and ultimately transformed the rural Indian communities from subsistence barter economies to cash and wage ones. On every front the old ways began to vanish. No organized structure had ever held the Indian painters together as a group, and now altered personal circumstances, economic necessity, and other reasons kept many painters from returning to their art in the postwar years.

The career of Cochiti Pueblo artist Joe Herrera (See-Ru, born 1923) spans this period. The son of Tonita Peña, as a young man Herrera demonstrated remarkable talent and a mastery of the Studio style. Shortly after graduating from the Santa Fe Indian School in 1940, he was sent overseas with the U.S. Air Force. Upon his return to the Southwest, Herrera enrolled at the University of New Mexico, earning a degree in art education. At the university he became increasingly interested in the modernist paintings of Raymond Jonson, one of his professors. Encouraged to move beyond the traditional painting style he had mastered in his youth, Herrera began to improvise, utilizing cultural motifs as graphic design symbols and applying earth colors with a splatter technique in a strikingly contemporary mode.

Herrera is truly a transitional figure. His distinctive Pueblo abstract style, which he calls abstract symbolism, represents an important milestone for Native painting. Rock art images, together with designs from pottery, kiva murals, and ceremonial paraphernalia, provide the cultural underpinnings, but the artist reinterprets them. Herrera exhibited his work widely in the early 1950s, earning many honors and

Petroglyphic Turtle, by Joe Herrera, Cochiti Pueblo, ca. 1952. Casein on paper, 22" x 19".
Joe Herrera was deeply committed to the success of the Southwest Indian Art Project because, he said at the 1959 University of Arizona conference, "Art used to be a part of everyday life to the Indian. This is no longer true. Students do not get stimulation from their families; they are no longer trained by their elders in the activities of the home." Herrera believed that a renaissance of Indian creativity was possible if young artists were introduced to the breadth of world art traditions and given the opportunity to experiment freely with techniques and materials.

national recognition. Most significantly, he opened the door for a transformation of the traditional style, paralleling the effect Oscar Howe's innovative abstraction was having on the Plains Indian painting tradition.

Overall, however, the 1950s saw an appreciable diminution of innovative vitality in the Indian painting genre. Although a few painters, like Herrera, pursued their independent visions, in large part Indian creativity had devolved into technically proficient arts and crafts produced for the tourist trade. The exceptional artists had few incentives to produce quality work, and in many ways this was an era of creative limbo. In 1954, the Denver Art Museum, long a mainstay of support for Native creativity, discontinued its annual Indian arts exhibition. Although many other traditional venues for Southwestern Indian arts and crafts continued, including the annual Indian shows in Santa Fe, Gallup, Tulsa, Scottsdale, and Flagstaff, curators and exhibition directors lamented the deteriorating quality of submissions and became ever more selective in their choices. The major traders who promoted quality Indian arts also kept up their efforts. In 1956, in an effort to revive traditions, encourage older artists, and provide an incentive for younger artists and craftspeople, the Museum of New Mexico inaugurated an annual exhibition of Indian artists. But many of those involved with the world of Southwestern Indian arts and crafts feared for its vitality and future.

Resurgence and Renaissance in the 1960s

An auspicious contingent of Indian artists and educators, along with museum and university leaders and dealers in Indian arts, was brought together at a convocation sponsored by the Rockefeller Foundation in the spring of 1959 at the University of Arizona campus in Tucson. The purpose of the gathering was to "exchange ideas on the present status and the possible future of American Indian art."

There was widespread recognition among the participants that, following the florescence of the traditional style in painting, many of those involved had unwittingly contributed to the atrophy of Indian art by their single-minded encouragement of one style. Native artists had no incentive to pursue personal aesthetics and divergent world-views. Southwestern Indian art had become market driven, catering to the tastes of

dealers, patrons, and collectors, and their imposed notion of "authenticity" was stifling creativity. The conferees further recognized that tourists and collectors alike were accustomed to paying next to nothing for Indian art—certainly nothing approaching a living wage. A resurgence in the field would require not only the stimulation and encouragement of Native artists but also a sustained effort to educate the public about the value of Native arts.

The Tucson conference gave birth to the Southwest Indian Art Project, a series of art workshops held during the next three summers at the University of Arizona. A number of Anglos participated in the initial conference and the summer sessions, but the intention was for Indian people to drive both the content and the outcome. This spirit is captured in comments from the conference recorded in the University of Arizona's *Directions in Indian Art*. As Mrs. Joe Herrera said, "the Indian himself must also do something about it, if only to show that he is interested in what happens." The summer program represented a real turning point for Native easel painting and the sustained development of Southwestern Indian arts in general, with Indians themselves taking charge of their creative future.

Many Native artists and arts educators participated in the Southwest Indian Art Project. Students were given opportunities to learn new techniques, try new media, and study world art traditions, with the encouragement of experienced mentors and teachers. Arts educator Lloyd Kiva New (Cherokee) underscored the program's theme: "Let's see that the young Indian realizes the values of his great and wonderful traditions as the springboard for his own personal and creative ideas." In most cases, these young artists were members of the first generation to grow up away from their ancestral communities—their families had moved into the Anglo world to make a living. The teaching emphasis was therefore on self-discovery, helping students reexamine their Native roots and integrate traditional values with the contemporary world. Corroborating New's comments, the eminent Hopi artist, designer, and craftsman Charles Loloma (1921–91) said, "New forms can come out of Indian backgrounds." Loloma's daringly innovative work made him an exemplary model for the students at the Southwest Indian Art Project.

One Navajo, by Fritz Scholder, Luiseño, 1968. Acrylic on canvas, 72" x 59 1/2". "In a way," Scholder is quoted by Ron McCoy, "I am a paradox. I have changed the direction of so-called Indian painting but I don't consider myself an Indian painter."

The immediate and tangible outcome of the project was the formation in Santa Fe of the Institute of American Indian Arts (IAIA), a two-year, federally funded art school that replaced the Studio program at the Santa Fe Indian School. For both Loloma and New, the IAIA was the realization of a dream they had almost abandoned. Both were involved with the school from the outset, as were other noted artists such as Allan Houser and Fritz Scholder.

During the 1960s the stagnating easel art tradition was replaced by a flowering of creativity and the emergence of the Indian artist as an individual. The social climate of the nation was changing dramatically at the same time. Propelled by the momentum of the civil rights movement, minority groups, including Native Americans, experienced a new spirit of empowerment. Things "Indian" took on an alluring cachet, due in part to the hippie generation's efforts to emulate the traditional Indian way of living on and with the land. A new and democratic spirit of pride in American culture blossomed across the nation, manifested most prominently in the establishment of the National Endowment for the Arts in 1965.

Fritz Scholder (Luiseño, born 1937) embodies both the spirit of the era and the changing dynamics of the Native American world. In the summer of 1961 he attended the Southwest Indian Art Project on a student scholarship, and the emphasis on personal exploration opened his eyes to the rich possibilities inherent in "Indian" themes. He at once began experimenting with them. The following summer he returned as a member of the faculty, now in a position to share his profoundly personal aesthetic and newfound insights. Scholder's unequivocal response of "No!" to the question, "Does an Indian artist have to work in a certain style or with a certain subject matter?" paved the way for the dramatic and radical new directions explored by Indian artists in succeeding decades.

The social protest and political ferment across the U.S. during the 1960s and '70s, incited by widespread misgivings about the nation's role in the Vietnam conflict, fed right into the resurgence of Native visual arts. Indian activists seized upon the oppressor theme and protested the government's treatment of their people. A strong genre of social protest art added its voice to the national conversation, and Native expression took a place in it. Adelyn Breeskin, chief curator of the Smithsonian's

The Restless Indian, by Tony Begay,
Navajo, 1970. Mixed media,
18 1/4" x 14 1/2".

A successful and versatile painter, Begay
captures in this painting the strident
politics of the 1960s and 1970s. Indian
activists gained attention at the time for
pressing Native issues by staging highly
publicized events such as the 1969
occupation of Alcatraz Island and the
1972 Trail of Broken Treaties March on
Washington, D.C., which ended in the
takeover of BIA headquarters.

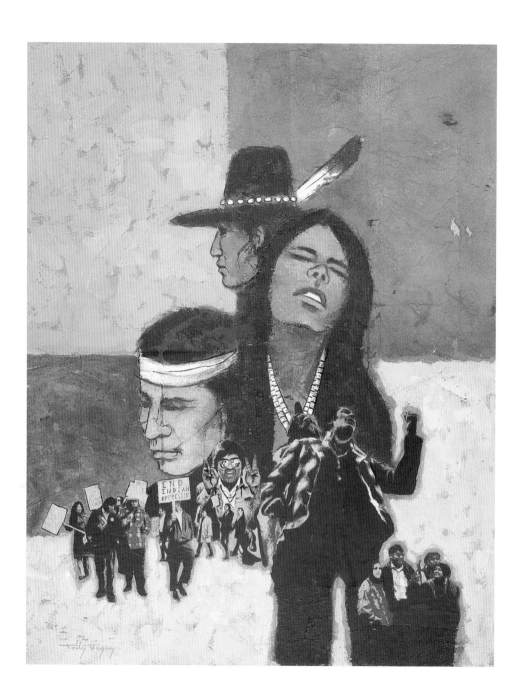

Eagle Dancer between Heaven and Earth,
by Mateo Romero, Cochiti Pueblo, 1991.
Acrylic on canvas, 38 1/16" x 28 1/8".
David Warren from Santa Clara Pueblo,
a seasoned observer of contemporary
Native issues, is buoyantly optimistic
about the resurgence of community that
he sees occurring across Native America.
In a talk Warren gave in Santa Fe in
1999, he called it "the return home of a
generation you'd have expected to move
on," pointing to the dramatic viewpoints
expressed by younger artists like Mateo
Romero. Warren's comments about the
younger generation of Native American
artists were made in a talk at St. Francis
Auditorium, Santa Fe, on March 21,
1999.

National Museum of American Art from 1968 to 1974, was an early and prescient observer of the phenomenon spawned by the IAIA. In 1972 Fritz Scholder and T. C. Cannon (Kiowa/Caddo, 1946–78), one of the school's first students, were given a two-person exhibition at the museum. It was titled simply, and significantly, *Two American Painters.*

But public acceptance of the multiple new looks of Native easel painting came slowly. Perhaps nowhere was there more resistance than in the Santa Fe art community. There, with certain notable exceptions, the new art did not receive strong backing and exposure.

Recent Years in the Southwest

There is little question that the Institute of American Indian Arts, the only school devoted solely to the cultural and artistic traditions of Native Americans, has fostered a nationwide Indian art renaissance. Countless exceptional artists have participated in its classes and served on its faculty. Its handsome museum, which opened in downtown Santa Fe in 1992, is a showcase for Native creativity and maintains an important collection of contemporary Native art.

All has not been smooth sailing for the IAIA during the more than thirty years of its existence, however. In recent years it has weathered internal strife and political turmoil and its federal support has been cut drastically, necessitating reductions in staff, programs, and student enrollment. Nevertheless, the IAIA today is poised for exciting growth. Loyal alumni and former associates are determined to see the unique institution succeed and thrive, and a committed president and Board of Trustees have launched a major fund-raising campaign. Joanna Bigfeather (Western Cherokee), the director of the IAIA Museum and an alumna of the institute, brings a sophisticated and national perspective to her work. In the fall of 2000, classes were held at the IAIA's new 140-acre campus south of Santa Fe. And while the ability of the institution to sustain itself has yet to be proved, this handsome new home could be a fitting capstone to this story of the emergence of the Indian as individual creator and provide further endorsement for an important genre of American art.

Within the Southwest, the Heard Museum in Phoenix has emerged as a premier advocate for contemporary Indian art. Its Biennial Native American Fine Art Invitational, launched in 1983, gives important exposure to cutting-edge Indian artists from across the nation. The museum maintains a high profile in collecting contemporary Indian art as well.

The print media, especially magazines, have also come to serve as important venues for contemporary painters. In the mid-1990s *Indian Artist* provided a vital forum for the many faces and voices of Native creativity. Now merged with *Native Peoples,* the periodical continues to serve as both showcase and forum for Indian art, as well as spotlighting a broad range of national Indian issues.

Another significant phenomenon is occurring in the publishing industry. The shelves of the "Southwest" sections of bookshops have become veritable galleries for the works of Native artists. Native creative writing—fiction and poetry as well as nonfiction—is flourishing, and the covers of numerous books, whether by Indian authors or simply with Southwestern themes, feature the paintings of contemporary Indian artists.

The creative dialogue taking place in the Southwest today is global in perspective. In truth, it is the contemporary Native artists, as visual commentators speaking from within the culture, who make the strongest statements about the Native condition today. Art has always spoken freely for its time and place. We now turn to look at the ten contemporary artists who participated in the Southwest Indian Painting convocation, at the multiple faces of the genre, and at the insights of these representative practitioners. Although they are regionally based and culturally rooted in the Southwest, there is nothing provincial about these painters. Their outlook is global and replete with universal themes.

The Artists

The Artists:

Top row, left to right: Marcellus Medina, Felice Lucero, Linda Lomahaftewa, Gary Yazzie, Diane Reyna.

Seated, left to right: Alex Seotewa, Mateo Romero, Michael Kabotie, Jeanette Katoney, Emmi Whitehorse.

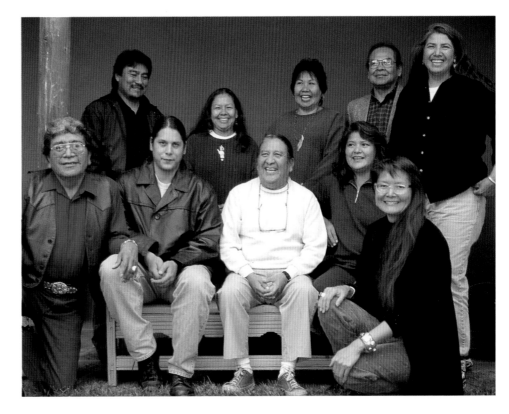

"The convocation strengthened my center place and my migration by being able to listen, learn, and share perspectives with the artists of the convocation."

—Diane Reyna

Michael Kabotie (Hopi)

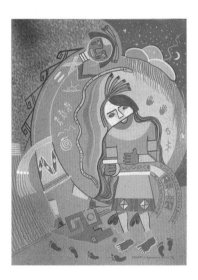

Snake Dance, by Michael Kabotie, 1968. Acrylic on mat board, 24" x 18". IARC 1985-20-64.

Hopi artist Michael Kabotie probes the inseparability of art and life. "To understand the world you have to find it in yourself," he says. "Art deals with the heart." He adds, "The arts are my journey. They are a religious ceremony I'm always going through." A man of generous spirit, Kabotie is both deep thinker and light-hearted clown, intensely interested in the human condition.

The artist's journey began at Shungopavi, a Hopi village at Second Mesa in northern Arizona, where he was born in 1942. His father was Fred Kabotie, the early traditional painter and internationally acclaimed artist and educator who thoughtfully confronted the issues of preservation of tribal values in the midst of a swiftly changing world. The family's experiences, therefore, were at the same time intimately engaged with traditional Hopi life and connected to the world far beyond their remote reservation home.

Kabotie says his father never encouraged him to become an artist—"He felt it was too hard." Consequently, after two years at Haskell Institute in Kansas, the younger Kabotie entered the University of Arizona, intending to study engineering. There he learned about the Southwest Indian Art Project and enrolled for the summer of 1960. One of Kabotie's instructors, whom he credits as a mentor, was Cochiti painter Joe Herrera, the traditionally trained artist who had broken from the constraints of the Dunn style and successfully forged an abstract style that would have widespread influence on the next generation of Indian painters.

The summer workshop proved to be an epiphany for Kabotie, leading him to the understanding that art is a universal language that speaks with many voices. As Kabotie says, "Art deals with the human spirit, and in those areas there are no bounds. When the sun rises it doesn't discriminate; it lights both the good and the evil." Just as Native American painters in earlier generations responded to the world they were familiar with, Kabotie realized that the contemporary artist must speak from personal vision and insight.

In the Pueblo world, initiation rites and most religious instruction take place in ceremonial chambers called kivas, and the kiva, perhaps more than any other single image, defines Kabotie both personally and artistically. The painting style, imagery, and colors of the kiva murals, particularly those of the ancient Hopi village of Awatovi, spoke directly to Kabotie's creative spirit and transformed

his personal aesthetic. Pointing to his initiation into the Snow/Water Clan in 1967–68 as a significant turning point, the artist says, "My real degree came from the kiva. The arts and that initiation made me human."

Following his initiation, Kabotie gained new insights into the dualities always present in life. He sees himself as a Hopi clown and trickster, and like the Hopi clowns, Kabotie often uses gentle jesting and humor to make a point. At the same time, he respects the so-called dark side of human experience. Paraphrasing the poet Robert Bly, he says, "In order to be enlightened we must first be endarkened." Kabotie acknowledges the dark times in his own past, including bouts with alcohol. "I was a wild man," he says. Paintings from that period of his life were done in dark, somber tones, often on a black background.

The early kiva muralists were also the inspiration for the Artist Hopid, a group of young Hopi painters Kabotie co-founded in the 1970s. As Kabotie says, the artists had a broad and noble goal: "to bring spirituality to the world through Hopi painting." During "The Deep Remembering" convocation, Kabotie viewed a painting by the late Bevins Yuyaheova, a member of

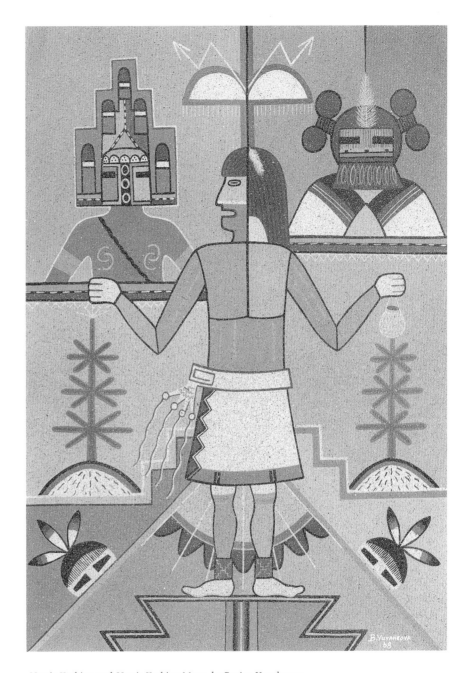

Hemis Kachina and Hemis Kachina Mana, by Bevins Yuyaheova, Hopi, 1968. Acrylic on mat board, 21 1/2" x 15". IARC 1985-20-28. Looking at Yuyaheova's painting brought a flood of memories about Kabotie's fellow painters in the group known as Artist Hopid. "It was an experiment. We began looking at the kiva murals, and we gave them a different spin."

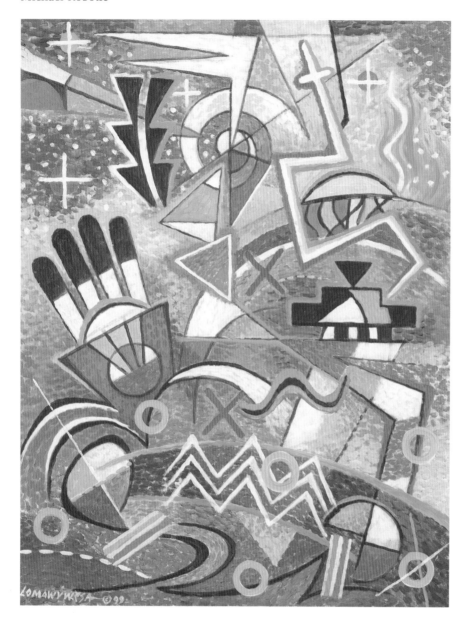

Ascending from the Deep Remembering, by Michael Kabotie, 1998. Oil on canvas, 28" x 22". SAR 1999-4-1.

"Today I'm involved in feelings. I'm not a technician, not analytical; I play around. I hear the chanting within, listening to my organs, my lungs, my blood, the gossip of my liver and kidneys. Dreams are the language of the body. They talk to me. My intellect has a BIG problem with that. It has to know, to understand. But my dreams are poetic, they talk in symbols.... They drive my intellect crazy."

the group, and recalled the close fellowship and deep tribal roots the young painters shared. The artists took centuries-old motifs from Hopi kiva murals, baskets, pottery, textiles, and ceremonial paraphernalia and interpreted them in a contemporary idiom, informed by their interest in aspects of world art history and new techniques.

As a painter, printmaker, silversmith, and poet, Kabotie communicates a personal vision replete with the esoteric imagery and language of his Hopi heritage. At the same time, his message is universal and speaks to the common spirit shared by all humankind. He expects to continue on the art journey all of his life, for like any true seeker he is constantly realizing how much more there is to explore. The richness of the world beckons to him.

Responding to the question of how the artist knows when he or she has succeeded, Kabotie says, "We have to have a sense of our own self-worth. I validate myself. It's important that each of us be where we're at."

Jeanette Katoney (Navajo)

Humpback Yei, by Joe Ben, Jr., Navajo. Sand painting, 50" x 15 1/2". Katoney credits her mother, weaver Alice Katoney, and Joe Ben, Jr., as mentors who helped her discover the beauty and creative resources of her Navajo cultural roots.

Jeanette (Jan) Katoney, a young Navajo mother and painter, serenely balances her commitments and the needs of her extended family with her personal creative path. The rewards are mutually beneficial, for members of Katoney's family provide both motivation and powerful role models.

"My inspiration comes mostly from the Navajo female weavers in my family," Katoney says. "My mother, Alice Katoney, has been a weaver all her life. Growing up on the Navajo Reservation near Dinnebito, Arizona, I was influenced by my mother, my aunts, and my grandmother."

Katoney now lives in the Hopi village of Hotevilla with her husband, the Hopi sculptor Bryson Nequatewa, and their daughter, Alicia. Bryson's mother, the renowned jeweler Verma Nequatewa, and her husband, Bob Rhodes, an educator, live nearby. Verma, who works under the name of Sonwai, carries on the creative traditions of her uncle, Charles Loloma. Thus Katoney interacts with and is continually inspired by people who are exploring and extending their own creativity.

Born in Winslow, Arizona, in 1967, Katoney studied architectural drafting in high school and was taught drawing in the Euro-American tradition. For a time, she says, "I thought, 'This is me.' But then I got into painting and color, which in turn moved me toward experimenting with abstraction."

As a student at the Institute of American Indian Arts in the early 1990s, Katoney discovered the depths of her Native roots and her potential as an artist. She acknowledges the many people who have believed in her and played important roles in her life. The Navajo sand-painting artist Joe Ben, Jr., is a close family friend and a mentor who urged her to explore not only ideas but also the materials of her ancestors. He helped Katoney see that her own culture was truly an art form and naturally an artistic language. "I learned to live in harmony and balance with myself." Today Katoney says unhesitatingly, "My art is a way of prayer."

In 1997 the Museum of Indian Arts and Culture in Santa Fe invited Katoney to participate in "Native Abstraction: Modern Form, Ancient Ideas," an exhibition organized to demonstrate that Indian abstract art is rooted in the natural world, in contrast to the predominantly non-objective abstraction of the Western tradition. At the time, Katoney was exploring painting with sand. "The earth is female in Navajo, so the sand gives me, as a

female Navajo artist, a great connection from which to develop artistic expression," Katoney explains. Recently, however, Katoney has put aside working with sand. "It was a challenge, but I've found I'm more of a painter." In her abstract work, Katoney feels she is carrying on a family tradition, reinterpreting it to fulfill her personal needs. She uses the European techniques she learned at school but says, "All of my ideas come from my roots and cultural background."

Katoney regards her life to date as a journey in three worlds, for the family participates in both Navajo and Hopi traditional life, as well as the larger culture beyond the reservation lands. The overarching and dynamic theme of Katoney's life, however, is the Navajo way: "The paintings are my prayer and meditation." The Navajo word *hozho*, which translates as beauty, harmony, and balance, is integral to the Navajo worldview. Certainly the life of Jeanette Katoney is a living tribute to the spirit of *hozho*.

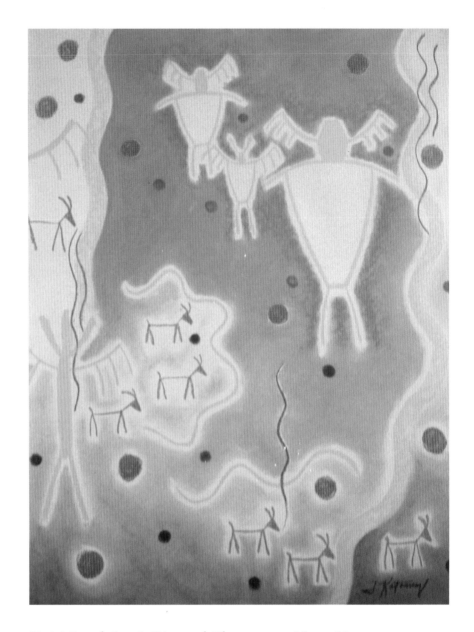

Hunter's Prayer, by Jeanette Katoney, n.d. Oil on canvas, 19 1/2" x 25 1/2".
The Navajo way is the overarching theme and dynamic of Katoney's life and art.

"My success is my life. Being at home, the fulfillment I get from doing my art, juggling all I need to, raising a family, taking care of parents. I'm happy where I am."

Prayer to the Four Directions, by Jeanette Katoney, 1998. Pastel on paper, 40 1/2" x 26". SAR 1999-4-2. "This is my prayer, to remember who I am and remember my people. 'The Deep Remembering' to me means tradition and culture. The hands represent the four directions, the spirals the journey to date, and the dots perfection. The dots also relate to the circle and the importance of centering oneself. The abstract style allows me to say something about my culture, but not too much."

Linda Lomahaftewa (Hopi-Choctaw)

"My style is contemporary and incorporates traditional symbols and motifs. My work reflects my strong sense of belonging and knowing myself."

"Study the masters," Linda Lomahaftewa was told by her instructors at the San Francisco Art Institute, where she earned her BFA and MFA degrees. The focus of teaching at the school was Euro-American; consequently, the "masters" were those revered in that tradition. Apparently it did not occur to the faculty that a promising student of Hopi and Choctaw heritage might be inclined to draw on other sources. Fortunately for Lomahaftewa, there was a strong support group of Indian art students in San Francisco in the late 1960s and early 1970s. Many of them had attended the Institute of American Indian Arts in Santa Fe during its bold formative years, and the exhilaration of that experience had forged strong bonds of fellowship. These friends, who included T. C. Cannon, Doug Hyde, and Earl Biss, supported one another in pursuing their unique artistic visions in the face of often uncomprehending teachers.

Lomahaftewa has spent most of her life in urban environments. Born in Phoenix in 1947, she lived for many years in Los Angeles and attended the Phoenix Indian School as a boarding student. Her Hopi father frequently took the family to his home on the mesas of northern Arizona, and these visits instilled in Lomahaftewa a strong sense of cultural identity. Like many of her generation, she is of mixed cultural heritage. She has found this duality valuable, serving to counterpoint and illuminate life experiences. Lomahaftewa says, nonetheless, that her mother's Choctaw heritage has never been a strong personal influence.

Family has been a mainstay and anchor throughout Lomahaftewa's life. "Even when they don't understand my work, they give lots of support," she observes. "My grandfather told me, 'Always remember who you are, and never give up.' He encouraged me to finish my education and return to help my people. I do this through teaching and encouraging young people in art."

Lomahaftewa has taught art at the college level for nearly thirty years, in California and at the IAIA, where she is currently professor of painting, drawing, and design.

As an educator, Lomahaftewa's goal is to instill self-confidence, self-determination, and a desire to work hard—characteristics that are her personal touchstones. "I tell my students

to approach assignments according to where they are coming from in their lives. Some assignments are to work in a culturally traditional style and depict lifestyle, scenery, and ceremonies." She wants to encourage young people to delve into personal experience for creative resources and hopes this search will lead to an understanding of the values of their cultural inheritance.

Lomahaftewa's own style reflects her reverence for the Hopi way. The masters who have served as her inspiration include the great Awatovi kiva mural artists, as well as aunts and cousins who make baskets. She also finds the detailed renderings of ceremonial and home scenes by the early traditional Hopi painters compelling and recognizes their importance for the historic record.

Lomahaftewa studied graphic and commercial arts in high school, expecting that some form of representational art would be her creative path. But when she began painting as a high school senior, she found herself irresistibly drawn to abstract work and to experimenting with color and form. "I felt confused about not doing traditional painting, because it was my source of inspiration—the colors, the

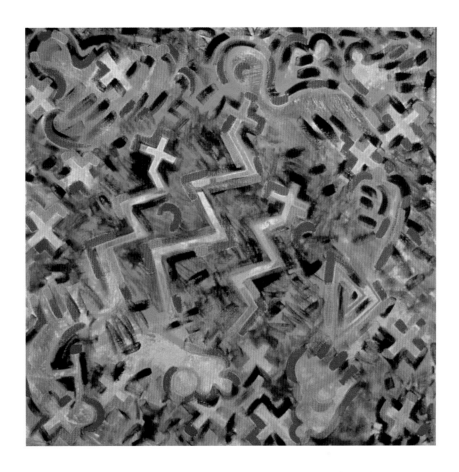

Remembering Grandfather's Stories, by Linda Lomahaftewa, 1988. Acrylic on canvas, 46" x 46". The fundamental and compelling spirit of Lomahaftewa's work is her strong identification with Hopi culture. "The tangibility of the Hopi way is inspiring. It is a way of life which just makes more sense."

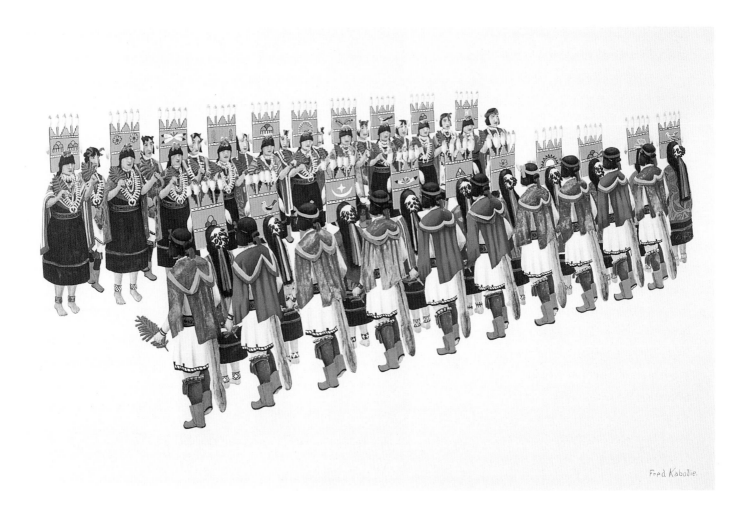

Fred Kabotie.

Butterfly Dance, by Fred Kabotie, Hopi, ca. 1928. Watercolor on paper, 14" x 21 3/4". IARC P212.

Lomahaftewa responds stylistically to the traditional Hopi painters, who, she feels, were poets with color, pattern, and design—elements of foremost importance to her own creativity. Acknowledging Dorothy Dunn's pivotal role, she says, "We can thank her for this record."

scenes of home life and dances." Lomahaftewa now understands that her art is indeed in the Hopi tradition, modified by her personal late-twentieth-century insight.

Following the dual path of art educator and fine artist is not always easy for Lomahaftewa. "Teaching takes most of my creativity; now I only work to create a show, based on deadlines." She admits that she does her best work under pressure, and she continues to maintain an active exhibition schedule, participating in the markets and fairs that promote Native arts. Fifteen years ago, Harmony Hammond and Juane Quick-to-See Smith quoted Lomahaftewa as saying, "For me, art is not just slopping paint around, but something very sacred and spiritual." This attitude of reverence and prayer continues to permeate her art and her life.

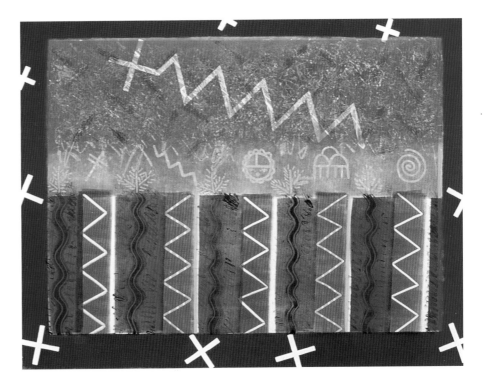

Prayers for Rain, by Linda Lomahaftewa, 1989. Monotype, 22" x 30".
"I am a contemporary painter inspired by clan symbols, petroglyphs, kiva murals, pottery designs," Lomahaftewa says. She recognizes that the traditional painters were sensitive colorists, something that is key to Lomahaftewa's own work.

Felice Lucero (San Felipe Pueblo)

"My work is based upon layer upon layer, as opposed to European point perspective. I have a circular way of working."

"Art is my effort to convey what it feels like to be a Pueblo person," says Felice Lucero. Contemporary Indian painting has been described as dealing with the survival of the spirit. This sensibility is nowhere more apparent than in the life and work of this painter, who melds a personal interpretation of her Pueblo roots with a highly trained knowledge of Euro-American art-historical philosophy and techniques. Lucero has lived in many places across the United States, only recently returning permanently to her native Southwest. "You must know the greater world to understand yourself and your place in it," she says today.

Felice Lucero was born in 1946 at San Felipe Pueblo, where her life revolved around a large and extended family, the cycle of the Pueblo ceremonial and religious year, and an ever-present relationship with the natural environment of her rural home along the Rio Grande. Perhaps it is not surprising that Lucero had to leave home in order to gain perspective on herself and her cultural roots. After dropping out of college in the mid-1960s, Lucero ended up in Los Angeles, where she worked for a time and immersed herself in the city's rich cultural scene. This odyssey provided her with learning experiences, friendships, and insights that greatly enhanced her worldview. In 1979 she completed a BFA degree at the University of New Mexico and began her active career as an artist.

Lucero was married to a Polish-Italian architect for many years, and the family, which includes two daughters, lived a peripatetic life following his career in academia. It was during this time that Lucero evolved as an artist. Free of tribal constraints, she studied art, lectured, and participated in exhibitions. Nonetheless, Lucero says, "The Sandia [Mountains] landscape was with me all the time." The marriage dissolved after the family returned to Albuquerque. Happy to be back in the Southwest, Lucero realized she had lost the wanderlust of earlier years; she had come home to stay.

Steeped in world art history and techniques, Lucero recognizes many influences on her creative voice. An obvious one is the Minimalist movement of the 1960s and 1970s, and she especially admires the spare, reasoned work of New Mexico painter Agnes Martin. But Lucero also thinks highly of the Dunn Studio artists, saying, "I respect the beauty of their world." She adds that they recorded a way of life that has since vanished. Lucero speaks with special fondness of Cochiti

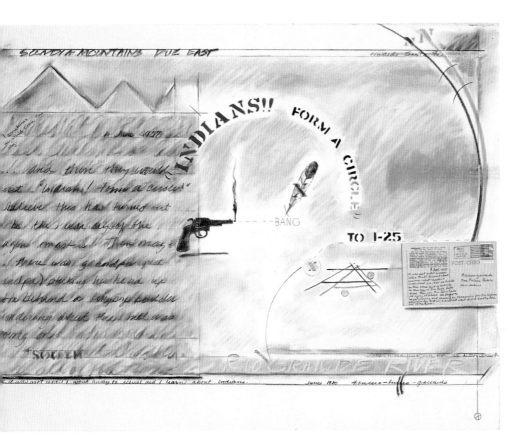

Indians! Form A Circle!, by Felice Lucero, 1980. Pastel, collage on paper. 30" x 22 1/4".
Felice Lucero's art is largely autobiographical, nurtured by the people, events, and landscapes of her childhood. "I talk a lot about those times in relation to now," she says.

Koshare, by Bob Chavez, Cochiti Pueblo, 1955. Watercolor or gouache on paper, 10 1/2" x 15". IARC 1989-28-59.
Manuel (Bob) Chavez started the art department at his alma mater, St. Catherine's Indian School in Santa Fe, just after World War II. While a prisoner of war, he had promised himself "that if I lived through it and returned home, I would devote whatever spare time I might have to the students at St. Catherine's," he told Tryntje Van Ness Seymour. Chavez's recognition of Felice Lucero's unique talents was pivotal to her career. Although Chavez worked in the traditional mode, he intuitively understood that this would not work for Lucero and urged her to follow her unique artistic vision.

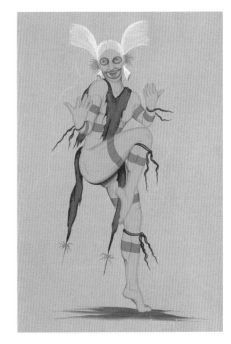

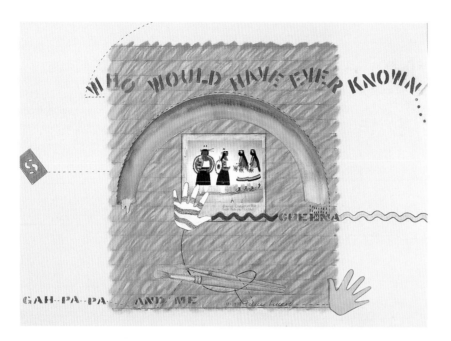

Who Would Ever Have Known, by Felice Lucero, 1998. Collage and mixed media on paper, 22 1/4" x 30". SAR 1999-4-3. "The old ones give you a deeper, fuller vision," Lucero says. In this work for the gathering she refers to her Gah-pa-pa, a beloved grandfather, koshare, medicine man, and tribal elder. Surfaces and textures are important to Lucero. She loves collage and will recycle even her own work if it has "sat around too long," tearing up a painting and incorporating it into a new image.

artist Bob Chavez, a beloved teacher at St. Catherine's Indian School.

A consummate storyteller and a prolific and inspired poet, Lucero keeps a daily journal, and much of her two-dimensional art relies on verbal contextual overlay. She has taken on the role of cultural caretaker of the ancient stories and myths of her ancestors. Her commitment grows out of a keen belief that tradition can be an important bridge to the future. Beyond that, she wants to add her own experiences and stories to the cultural continuum: "My art is a diary of my growing up."

The role of women, both inside and outside the traditional culture, has long interested Lucero, and her work contains many references to the female. Yellow, a color she uses often, symbolizes the female in her Pueblo tradition. Many of San Felipe's religious and ceremonial traditions are closely guarded and out of bounds to those outside the pueblo. As a woman, Lucero has found that additional areas of her culture are taboo as well. These prohibitions present her with an intellectual dilemma. Without infringing upon the restrictions, she cannot fully conserve the tribal stories and traditions and fulfill her role as a preserver of the culture. Every time she sets her writing pen or painting brush to paper, she wrestles with the possibility of overstepping boundaries.

But Lucero believes tradition lends stability and roots to one's life. "I am frightened by the world I am exposed to," she says. "A dialogue with young people is very important. The younger generation has no centeredness." She looks at young Natives as her "adoptees" and hopes to help them resolve their malaise and feeling of purposeless through the stability she believes they can find in their culture.

With humorous self-deprecation, Lucero laments a paradox of her artistic career. Because her work is untraditional, it is frequently rejected by juried Native exhibitions as well as by the authors of books on Native American art. Lucero says, "I just do the work because I need to do it. I don't ask questions."

Marcellus Medina (Zia Pueblo)

Marcellus Medina has forged a life in art that reflects the timeless traditions of his Zia Pueblo heritage. In subject matter, imagery, color, and style, he paints from a cultural perspective. Asked why he became an artist, Medina has a ready response: "It's because of what's inside of me."

"I basically grew up in the art world," says Medina, who was born in 1954 into a family of artisans, many of them accomplished potters. He speaks respectfully of the earlier traditional artists, calling them his "Native masters." Foremost among this group is his father, the well-known painter Rafael Medina (1929–98), who was his only teacher. Rafael taught his son the basics of composition and anatomy and then "turned him loose." Marcellus also speaks with admiration of his mother, Sofia, a talented potter, who taught him about color as well as about pottery, sculpture, and figurines. The couple frequently collaborated on pottery, Rafael decorating Sofia's pots with brightly colored, realistic images of Zia dancers and traditional motifs, usually in acrylics. This tradition has been passed along to the younger Medina and his wife, Liz, who also collaborate on pottery.

Medina is confident that traditional painting is alive and well, and he is comfortable with his adaptation of the style. "I started painting in the 1970s because of my family's tradition, the support of many people, creative inspiration, and economic motivation," Medina says. He aspires to follow in his father's footsteps, expanding upon the elder Medina's colorful portrayals of traditional Zia subjects. He hopes, as well, to attain a similar measure of success in the marketplace. Medina knows which subjects have the most popular

Beginning of the Corn Dance, by Rafael Medina, Zia Pueblo, 1966. Casein on colored board, 18" x 24". Marcellus's father, Rafael Medina, attended the Santa Fe Indian School, where he studied with Velino Shije Herrera, the traditional Zia painter who was one of the original pioneering artists, and Gerónima Cruz Montoya. This painting is one of his more elaborate and sophisticated compositions, exhibiting his occasional interest in experimenting with abstraction.

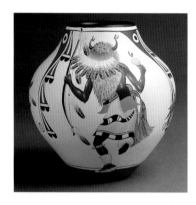

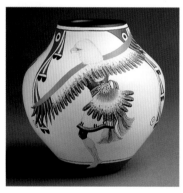

Pot, by Marcellus Medina and Elizabeth Medina, 1990. 5 1/2" high. IARC 1998-7-1.
In the style pioneered by his parents, Rafael and Sofia Medina, Marcellus paints in acrylics on Liz's hand-coiled, traditionally fired pots. Traditional Zia pottery is made from red native clay and covered with a white slip. "The red represents the earth and that which is 'below or before' the present earth. The designs on the white slip above represent what comes from the earth or what takes place in this world."

appeal, and these have become his stock in trade. Eagle dancers, he says, are especially in demand, as are landscapes incorporating Zia Pueblo in its high desert setting under a great, cloud-filled sky.

Working only in watercolor, Medina utilizes the subjects, colors, and scenes that have been a part of his life since childhood. He loves color, especially the traditional colors of Zia ceremonial life: yellow, blue-green, red, white, and black. An articulate spokesman for Zia culture, Medina respects his heritage and guards its traditions. For two years he served as the pueblo's lieutenant governor. Nonetheless, he knows that some members of the tribe consider him a "weekend warrior," because although he lives at Zia, he mingles freely in the outside world and is convinced that Indians must change and adapt with the times. More than a decade ago he was quoted as saying, "We can't live in the past. In order to succeed in this modern world you have to change with the times. One side pulls each way. We can't choose. We live in both worlds."

Medina speaks frankly about having experienced such problems as family disputes, alcoholism, discrimination, tribal jealousies, and political strife. Working

through these situations has deepened his understanding of himself as an individual, father, and tribal member. "They have made me a better person," he says. His dream today is to open an art gallery that will serve "my family, my community, and my tribe."

Zia is one of the most conservative of the Pueblo villages, and both Medina and his father have had bitter run-ins with the tribe over subjects they represented in their art. At one time, he says, his father was subjected to such scathing punishment that he had a nervous breakdown. Marcellus himself has been seriously criticized. "Art and politics don't mix," he notes, with evident frustration. "Regardless of one's intentions, community censure can result." Yet he makes it eminently clear that he respects the sacred aspects of Zia culture.

Ever a pragmatist, Medina understands that his life is a balancing act between two worlds. As a Zia Pueblo traditionalist, he defines his painting *The Deep Remembering* as "going back to the ancestors, how we emerged as one people, no color, no race, no prejudice.... It allows hopes and dreams."

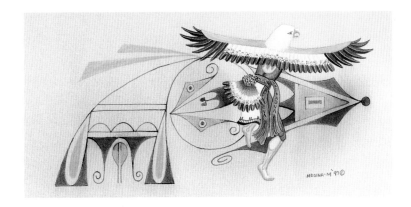

Eagle Dancer, by Marcellus Medina, 1997. Watercolor, 6" x 12".
Medina describes how he gets started on a new painting. Declaring "I'm God with a blank piece of paper," he immediately brushes a swath of color on the sheet, thus breaking the invisible barrier of the blank page. "I work spontaneously. I do what I want and don't change it. I already have the colors and subjects in my head.... The ideas just come."

The Deep Remembering, by Marcellus Medina, 1998. Watercolor, 19" x 25". SAR 1999-4-4.
"If you get away from meaning and focus on line, color, spirit, then art is felt. My primary goal is to produce a work of art that would express an idea, style, emotion, or a conversation that never ends."

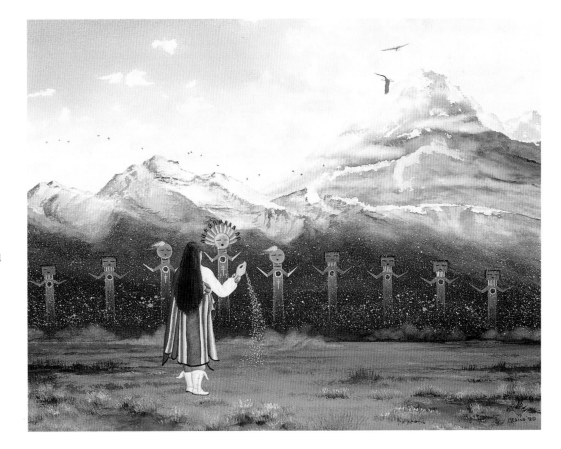

Diane Reyna (Taos Pueblo)

"My work is about energies translated in Pueblo icons. The work is not about me but about my experience."

"This is a journey," says Diane Reyna of her lifelong engagement with art. Reyna's journey of exploration, propelled by an innately creative spirit, has taken twists and turns, but the destination, an ever deepening personal understanding of creativity and its multiplicity of manifestations, has been constant. For almost twenty years she was a videographer, producer, and director, and she has also sculpted in wood, stone, and bronze. Today she works primarily as a painter with oil pastels on paper. Stacks of sketchbooks, the accumulation of years of ideas, fill her home and studio.

Reyna was born in 1953 at Taos Pueblo, where her family ran an arts and crafts shop. She virtually grew up in Tony Reyna's Indian Shop, amid the continual coming and going of artists and craftspeople. There, she absorbed an appreciation for the traditional beauty of the arts of many Indian tribes.

Reyna is a self-taught artist. "My art education came from my parents," she says. "They talked about quality and innovation. They were always open to new ideas and interpretations." Clearly, Reyna's family has always been central to her life. She speaks warmly of "two amazing parents who never gave up on us.

They encouraged us to do whatever we wanted to." The memory of her late mother, the painter Annie Cata Reyna from San Juan Pueblo, remains an abiding influence.

"A creative life is a sacred life," Reyna believes, and she says prayers as she starts a new day in the studio or places a crisp sheet of paper on the easel. This quiet, serene woman muses that her inspiration comes from a source higher and more powerful than the individual and that the roots of inspiration and creativity come from deep within inherited ancestral traditions. Often, when viewing a completed piece, she admits, "I can't believe that I did it!"

Reyna has long been interested in the lives and careers of the early female Native painters. She recognizes the hurdles they faced in going outside of the culturally accepted role of homemaker to pursue their art. Male Indian artists looked askance at them; women might be potters or weavers, but painting was considered a male activity. In particular, she singles out the Santa Clara Pueblo artist Pablita Velarde for her role as a groundbreaker who forged a painting career against formidable odds. Velarde's early work, Reyna adds, affirmed the woman's

point of view, depicting activities that were women's responsibilities in traditional community life.

Reyna's parents encouraged their children to get an education so that, she says, "we would have options and something to fall back on." After pre-law studies at New Mexico State University, Reyna transferred to the University of New Mexico. There she concentrated in video production, a career she pursued for many years. Her work on the Peabody Award–winning PBS documentary *Surviving Columbus* immersed her in Pueblo history and deepened her understanding of regional cultures and their distinctive worldviews. Today she teaches a course in video at the Institute of American Indian Arts. In the summer of 1998 Reyna was a Dubin Fellow at the School of American Research. The gift of time afforded by the fellowship enabled her to give up her part-time job at a foundry and explore her creative energies on a full-time basis.

Broadly defined, Reyna is an abstract artist. The essence of her painting and drawing style is imagery abstracted from the Pueblo symbols that surrounded her as she was growing up. Reflections of the landscapes of the vast Taos plain and the

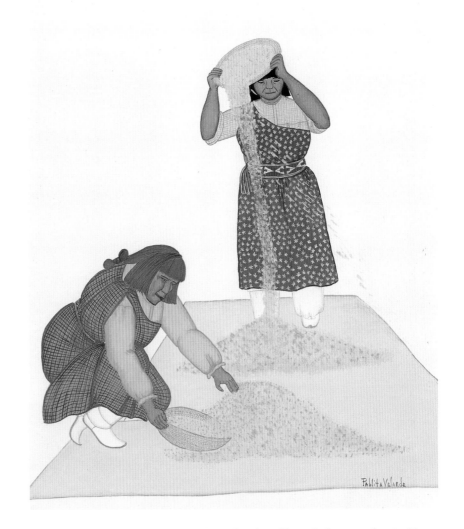

Sifting Wheat, by Pablita Velarde, Santa Clara Pueblo, 1952. Watercolor on paper, 14 3/8" x 9 3/8". IARC 1989-28-144.
Reyna says Velarde's work "gives us a visual record to be appreciated and learned from. It is a reminder to me of my past."

surrounding mountains, cut deeply by the undulating Rio Grande, also find their way onto her paper. Reyna works predominantly in oil pastel on black Arches paper. The clarity of her brilliant imagery, the flowing lines, swirls, and geometric patterns that build one upon another, provide striking counterpoints to the black ground. In the fluidity of her line drawings may be found a seamless kinship with the grace and flow of her earlier work in sculpture.

Possessed of a powerful sense of individuality and integrity, Reyna refuses to compromise for the sake of the marketplace. She has said that she will not actively promote or market her paintings; rather, her work is known by word of mouth. "I want to control the pace in order to maintain control of my creativity." Reyna's journey through art, a sustained and lifelong one, has yet many paths to follow.

Untitled, by Diane Reyna, 1998. Oil pastel on black paper, 22" x 30".
"I love working on black—the luminosity, the way it brings colors out."

Untitled, by Diane Reyna, 1999. Pastel, 32" x 30". SAR 1999-4-5.

"This piece represents my personal migration, my unveiling life. This is represented by the unfolding spiral within the piece. This migration is supported by symbols representing enduring strength—my Pueblo self, my courage and trust. The subdued colors evoke the solace of my life. The opportunities for continued growth are represented by the seeds spread throughout the piece."

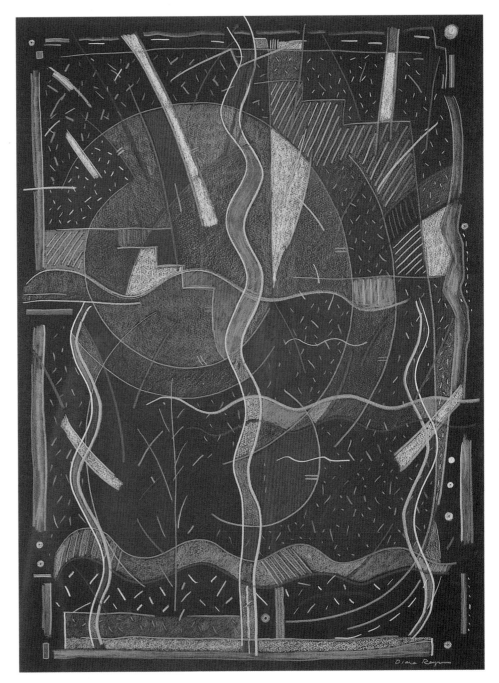

Mateo Romero (Cochiti Pueblo)

"The process of making art is important to me. I believe in expressing my vision."

The collision of two worldviews and the complexities that characterize life for many Indians today are the keys to the heart and the art of painter Mateo Romero. A thoughtful and analytic man, Romero finds the art process both highly intellectual and endlessly creative. His paintings have the same searing honesty found in the work of Fritz Scholder. Scholder's comment to Tony Schmitz in the mid-1970s—"I have painted the Indian real, not Red"—could be applied to Romero's work in the 1990s.

Romero paints from personal experience. His subject matter deals with family stories, cultural scenes, and an unvarnished view of the contemporary Native experience. His compositions are fraught with dynamic tension, and the theme of cultures in conflict and the strains and dualities in Indian lives today pervade much of his work.

Born in 1966 and raised in the San Francisco Bay area, Romero, like many of his generation, has chosen to return to his Pueblo roots. His art penetrates the surface of Indian life to spotlight societal ills. With real anguish, he asks, "What about the next generation? My concern is for our youth; they are making enormous transitions and are most affected by all the changes—the overlap of cultures, loss of language, moving off the reservation, intermarriage, the cultural otherness of mainstream society. The process is in place and can't be arrested. What are we doing for them?"

Romero identifies with the conflicts, both internal and external, facing young Indians today. "I am of the younger generation, a product of affirmative action," he says, explaining his Euro-American art background and privileged educational opportunities. In 1989 he graduated cum laude from Dartmouth College with a BA in visual studies and art history. While an undergraduate he enjoyed opportunities to study in Mexico and Spain. Subsequently he earned an MFA in printmaking at the University of New Mexico.

Trained in theory, history, and technique, Romero is a painter's painter who delights in the creative process. Curious about new techniques and trends, he thoroughly enjoys experimentation and its serendipitous consequences and is fascinated by the challenges of working with computer and video technology as well as performance art. At the same time, he loves the tactile qualities of painting, the sheer act of applying the brush to a flat surface and building color upon color,

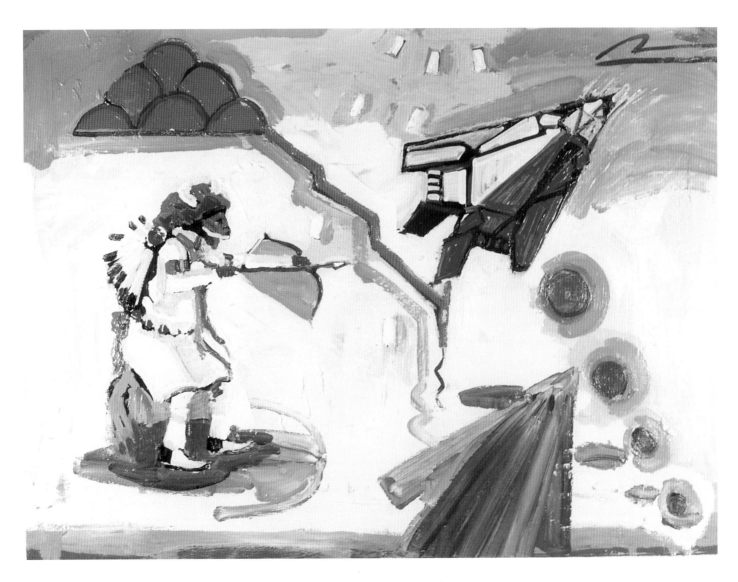

Shooting a Stealth, by Mateo Romero, 1999. Acrylic on canvas, 20" x 30".
"What is essential in art is an investigation of Indianness."

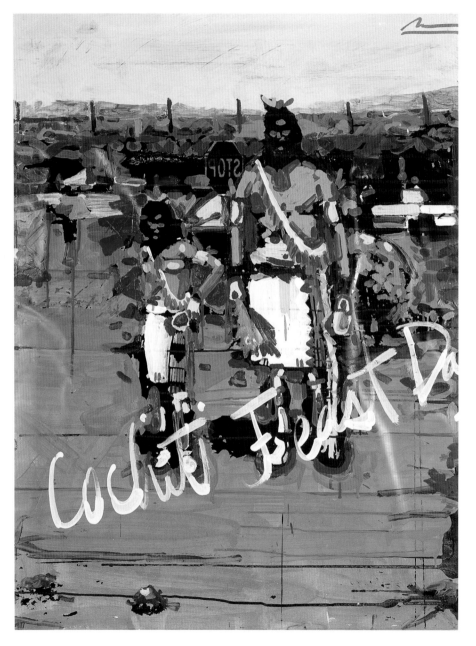

Primogeniture, by Mateo Romero, 1977. Mixed media, 44" x 34".
"Art must be germane today."

stroke by stroke, to create form and give content. Romero blends his creativity with a keen social conscience, exploring the dualities and the emptiness he perceives in many contemporary Native lives. "People victimizing themselves has become a major theme in recent years," he observes.

Romero does not consider himself an iconoclast, nor does he have solutions to social problems; he just knows that the personal toll on Native people has been steep. In painting their world in a mode that is gutsy, elemental, and occasionally brutally frank, the artist expresses a longing to touch hearts and perhaps strike a responsive chord that will change lives. One thing he wants to make clear: "My work is done with a loving hand, even when it's critical."

Interestingly, this very cerebral artist confesses, "Sometimes I myself don't quite know what my paintings mean." Romero admits that he enjoys playing the devil's advocate, acknowledging that there are no immediate answers to most of the questions he raises. "Its fun to ask the questions. There aren't any answers, mostly just wide-open questions."

Romero is driven by two equally strong forces: pleasure in the creative act

Pray for Rain, by Mateo Romero, 1998.
Oil pastels on paper, 30" x 39 1/2".
SAR 1999-4-6.

"I do no formula painting. The physicality of the process and the exquisitely personal and meditative act of creation are what motivate me. Making marks is like a prayer."

and a desire to express certain core beliefs. Describing his art as personal work, he says, "It has to be important to me, and I'm grateful when it reaches people." Romero is unwilling to compromise and refuses to appeal to a popular audience by doing what he has called "formula" work. Above all, he prizes the freedom of innovation—the honest response to an inner creative necessity.

Discussing the theme of "The Deep Remembering" convocation, Romero contrasted the community values of traditional Indian societies with the emphasis placed on individual accomplishment in the Anglo-European world. He blames the culturally destructive emphasis on "selfness" for much of the unhappiness in Native

America today. Romero has the highest regard for tradition and calls himself a conservative with respect to his heritage. He respects the esoteric and secret aspects of cultures: "Communities have the right to enforce cultural copyright. It's important that Native artists have a sense of responsibility. This is different from the position of artists in mainstream society, who are critics in an almost irresponsible way." He acknowledges, however, that "in our own communities, Indian artists are suspect.... We aren't seen as culturally grounded." Romero hopes to change this perception and win the respect of his peers through the loving integrity of his artistic vision.

Alex Seotewa (Zuni Pueblo)

"Never be afraid of color. Explore! Experiment!"

Alex Seotewa describes the Zuni tribal elders who have been his mentors throughout his life as his "library of wisdom." Seotewa has committed his life to preserving and imparting the cultural heritage of the Zuni people. Now in his late sixties, the genial artist himself is a library of wisdom.

Seotewa's major work, a series of murals depicting the ceremonial life of the Zuni people, has been in progress for almost thirty years. The murals cover the walls of the pueblo's restored mission church, Our Lady of Guadalupe. The project has brought Seotewa international renown, awards, and opportunities to travel as a cultural ambassador for both the Zuni people and the United States. Visitors from around the world come to Zuni to view the magnificent interior of the church, which is a national landmark, and to meet the artist. None of this attention has turned Seotewa's head. "I am always a student, always learning," he says simply.

Alex Seotewa was born at Zuni in 1933. His father, Charlie Chuyate, was a farmer and rancher who also worked as a commercial sign painter and traditional artist, often painting under the name Patone Cheyatie. Seotewa has vivid childhood memories of tending the family herds, the arduous spring lambing time, and the long hard days of work when the sheep were sheared. His father's love for the stark Zuni landscape left a lasting impression on the young Seotewa. "My dad was a poet with words. He loved the geography, the long piñon-dotted mesas, the red canyon walls rising off on the horizon, the mountains and trees." Seotewa remembers that his father was also fascinated by rock art and would talk to him about the ancestors who left enigmatic marks and drawings on the canyon walls. Charlie Chuyate must have felt a kinship with these early muralists, for he himself painted murals in the rectory and church of St. Anthony's near Zuni.

The death of his mother when he was only five left a great void in Seotewa's life, but his grandparents, especially his maternal grandfather, an important Zuni priest, took on the task of teaching him the traditions of his tribe. The older man's guidance and wisdom shaped the boy's character and laid the foundation from which Seotewa works today as he, in turn, teaches Zuni youth traditional values and philosophy.

World War II severely impacted Zuni families. Most of Seotewa's uncles and

Mountain Sheep Dancers, by Patone Cheyatie (Charlie Chuyate), Zuni, 1929. Watercolor, 19" x 24". IARC P55. At conservative Zuni Pueblo, early artists got in trouble for making images of ceremonial figures on paper. "My father signed the names of deceased relatives to his paintings of kachinas to protect himself," recalls Seotewa. On viewing this very rare dance scene by his father, Seotewa said with emotion, "It touched my heart."

cousins were drafted and sent away to fight. "At the age of twelve, I took over the men's jobs, caring for the stock and fields. I experienced how to survive." Poverty was a constant, but Seotewa sees now how rich life really was during those simpler times. Sharply etched in his memory is the freedom of the days when he roamed the countryside at will. That memory blends with others that recall the annual cycle of the Zuni ceremonial year, the subject of the murals on the restored mission's walls.

Seotewa was drafted to serve in the Korean War, which proved a bitter experience. "War," says Seotewa, "is a dirty job."

Returning to the reservation, he found readjustment difficult and began drinking heavily, seeking an escape from the ugly memories. Seotewa admits he was adrift during those years, unable to resolve the values of his traditional upbringing with all he had learned about the world beyond Zuni Pueblo. Then, one Sunday, "Somebody touched my mind.... Maybe it was grandfather's spirit, or my late mother, or maybe the Man upstairs. While I looked the same man, inside I changed."

Out of that epiphany emerged Seotewa's resolve to serve as a mentor for the youth of his community and to preserve visually the traditions and culture

of his Zuni people. Thus was born the project that has earned him the title "the Michelangelo of Zuni."

Seotewa has always loved to draw. As a child he whittled charcoal drawing tools out of coals from the stove and sketched familiar scenes on discarded cardboard boxes. He took art classes in high school and enrolled briefly in art school before the Korean War. During his years in the army, he worked as a sign painter. However, Seotewa states that none of his formal training influenced his style. His desire has always been to paint and draw Zuni subjects in the traditional way. Since he has a photographic memory, he never sketches; when he sees a "great scene, perhaps when driving on the highway... with a click of my eyes," he has saved it in his memory.

Seotewa recognizes the responsibili-ties he has assumed as a keeper and preserver of the tribal wisdom. "I'm in a fishbowl with my people, with the scholars [who come to study Zuni culture through his art], with the world." He has been criticized by some within the highly traditional Zuni community for exploiting the religion for the sake of his art. The church murals provide a forum where he can exercise his talent as a traditional painter while preserving for future generations the ceremonial heritage of the Zuni people. Seotewa demonstrates the anomalous duality of his own life, drawing from one pocket the cross that he always carries with him and, from the other, a buckskin pouch of sacred corn-meal. Chuckling, he says, "I'm more a sinner than a saint."

Seotewa understands the tremendous problems facing young people today. He too has been through deep waters and found his answers in traditional Zuni life, and his painting *The Deep Remembering* is his answer to the per-plexities of contemporary life. Through his life and his art, Alex Seotewa is committed to sharing this philosophy with the next generation.

Emmi Whitehorse (Navajo)

"Art is an intimate, personal thing. It goes beyond religion; it deals with space and a sense of displacement. I'm always looking at nature, the space around me."

Comparing herself to the Classic-period Navajo weavers she admires, Emmi Whitehorse explains, "Navajo women used to buy European-made blankets, unravel them, and then reweave the yarn into Navajo-style blankets. I want to take the European influence, unravel it, and make it Navajo."

Whitehorse laments the fact that Native Americans "are the only minority group that seems to never get beyond a 'segregated' state." But labels matter little to this artist. In her own life and career, she has resolved the issue, declaring: "You either are too Indian or not Indian enough...so to heck with it! I'm an artist who happens to be a woman. That's how I project myself."

Whitehorse was born at Crownpoint, New Mexico, in 1956. "I grew up in the open," she says, recalling childhood summers when the family took their livestock to the high summer pastures and lived a nomadic life, following the grazing animals. This articulate, highly educated, sophisticated woman acknowledges that her self-confidence was hard won. Her years attending Indian boarding schools in the 1960s and 1970s left her without a sense of identity, and for some time she suffered from low self-esteem.

Whitehorse received a bachelor's degree from the University of New Mexico in 1980 and an MFA in printmaking two years later. She acknowledges a certain debt to her university training, especially a lifelong love for working on paper, but speaks of a restrictive atmosphere in which she was not permitted to express her personal cultural memory. She says she floundered for some time, trying to achieve an artistic identity based upon an imposed standard.

It was not until a friend encouraged her to return to her roots for inspiration that Whitehorse found her artistic voice and flourished creatively. At this point, like the weavers she reveres, she was able to unravel the European influences and subordinate them to her Navajo vision.

Her grandmother, a weaver, was a great mentor. In Whitehorse's view, this grandmother was a painter at her loom, an artist who wove her identity and sense of self-worth into her textiles and visualized the completed piece long before it emerged from her loom. Whitehorse feels that weavers are never fully appreciated for their artistic achievement and believes that textiles are the result of the same sophisticated aesthetic as a painting, yet, she says, "I exhibit in a

Another Blanket #411, from the "Blanket Series," by Emmi Whitehorse, 1983. Mixed media on canvas. 27 1/2" x 37 1/2".
"I like to incorporate traditional beauty and aesthetics in my work, but this went against the rigid thinking in graduate school."

fine arts museum while the textile ends up on the floor."

Whitehorse rarely begins a painting with a particular idea. "I jump right in and make a mess...and then try to do something to make sense of it." She loves the freedom and spontaneity of the monoprint process and says that her monoprints serve as inspirations for her paintings.

"I work fast and from different directions," Whitehorse comments. "Often I have trouble determining which orientation will be the top of the piece." Even on large-format paintings, Whitehorse works on a flat surface rather than at an easel, and she usually approaches on her paper from several sides. Thus her works, much like the Navajo textiles that have often served as their springboard, emerge with an ineffable completeness in terms of balance and harmony. Recently Whitehorse's artistic focus has turned to the environment and landscape, and she finds that her painting has become more subdued.

Whitehorse connects the adaptability and multiple orientations of her art to the way she was brought up. In the wide-open spaces of the Navajo Reservation, she says, there was "no sense of fixed

things; the light, everything...shifted and changed throughout the day." In a Tucson Museum exhibition catalog written by Tisa Sherman and Robert Yassin, she explained further: "From a Native American perspective there is not a fixed plane. The horizon and earth are not separate. They always meet somewhere in the distance."

"Change is inevitable, and we must incorporate the change in our lives." The adaptability of Whitehorse's viewpoint allows her to critique what she considers a root concern for contemporary Native painters. "The Native artist or craftsman seems to be forever in a preserving state. We get coddled by every institution, which is really detrimental and keeps artists in a complacent mood. It's the Indian way; we don't contest. Our aim, rather, should be to tap into the global art world." Whitehorse sees the opportunities presented by computer and video art as creating a level playing field for artists. With the new media, any artist, irrespective of cultural background, is starting with a tabula rasa, experimenting with and creating completely unique and new art forms.

Whitehorse's perspective today is a global one. For many years she lived on the East Coast and traveled and exhibited

Navajo chief blanket, 1860, 56" x 75".
IAF T71.
"I find I'm more influenced by weavers than painters. This blanket is from the mid-nineteenth century, yet it looks like an Agnes Martin painting. The piece incorporates the male and female, the dark and the light."

in Europe. She recognizes that public validation of her vision has enabled her to pursue a highly individualistic artistic course, grounded by cultural ties but continually transcending them. To be an artist, she says, "You have to be out there.... Artists have been the first to say that the king is wearing no clothes." Like the weavers who influence her artistic vision, Emmi Whitehorse paints tapestries of color and light that speak eloquently of the contemporary Navajo woman's synthesis of her several worlds and her adaptation of culture and environment.

Rooting, by Emmi Whitehorse, 1995. Oil and chalk on paper, 50" x 38 1/4". SAR 1999-4-8.
"In the final analysis, you don't control your environment, it controls you. I don't really know where I am going. There is no sense of fixed things."

Gary Yazzie (Navajo)

"I started in the art business as a grown-up man. My influences are non-Navajo."

In his paintings, Gary Yazzie re-creates the vibrant activity of the rural, more traditional world of the Southwestern Indian. Yazzie's Southwest teems with the life of powwows and ceremonials, rodeos and ropings, fast-paced horses, and wide-open spaces.

Yazzie studied at the American Academy of Art in Chicago for three years in his mid-thirties and was trained in the classical art traditions, with heavy emphasis on the Euro-American representational style. He has successfully honed and developed this style over the past two decades. His skill is in documentary drawing, quick sketches, and the ability to capture colorful panoramas of Indian life. Yazzie's grounding in the use of color was developed in art school. The remarkable collection of French Impressionist works at Chicago's Art Institute gave him a whole new understanding of the subtleties of color and transformed how he looked at things.

Yazzie loves the contemporary western art genre popularized in the twentieth century by such artists as Charlie Russell, one of his earliest idols. Leafing through Yazzie's scrapbooks of personal memorabilia, one gleans insights into the artist's tastes and some of his other heroes. Here is preserved a reproduction of an oil painting by Taos School founder Joseph Sharp, of a noble Indian sitting in a rocky landscape. Gerald Curtis Delano, whose biographer called him "Painter of the Navajo," was another inspiration. Yazzie has made copies of the tranquil scenes of Navajo riders for which Delano is widely known. His contemporary Clifford Beck is another Navajo artist whose work Yazzie admires. The scrapbooks and portfolios also chronicle Yazzie's participation in the annual circuit of Indian shows, marketplaces, fairs, and art festivals across the country. Explaining why his art has taken the popular and commercial route, he says, "I've tried to live solely by art." Oklahoma has been Yazzie's home since the late 1980s; not surprisingly, his recent work includes many Plains Indian subjects, scenes that are perennially popular in the marketplace.

Yazzie does many quick sketches and enjoys life drawing. Primarily, however, he works indoors from photographs. Participation in powwows and other Native social gatherings has provided the rich pan-Indian subject material of his art. Several recent large-scale commissions have increased the artist's public visibility. One, a mural titled *The Ancient Ones,* depicts life in the cliff dwellings of

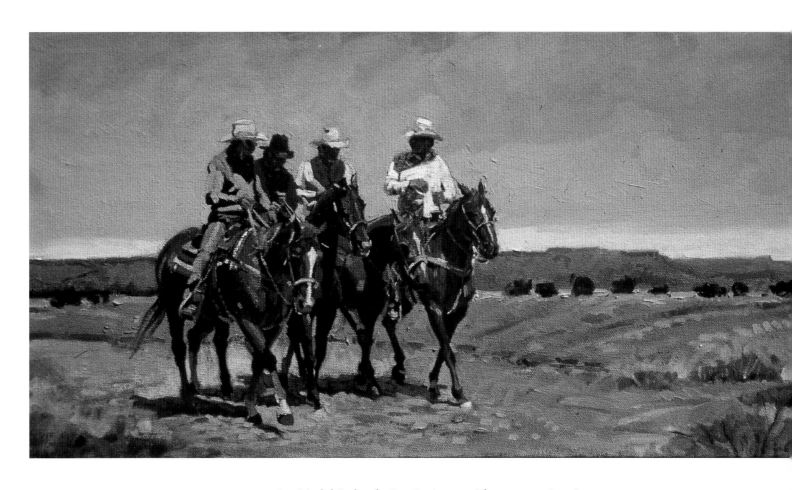

San Cristobal Cowboys, by Gary Yazzie, 1999. Oil on canvas, 10" x 20".
Yazzie uses art as a vehicle to discover a heritage he has never known well.
"I love the West. I love horses. The Navajo tribe is still a horse culture. This
depicts the ordinary things I have seen. I recognize how commercial it is."

Journey, by Clifford Beck, Navajo, 1987. Pastel on paper, 25 1/2" x 35 1/2". IARC 1990-6-3.

Yazzie has great admiration for the masterful Navajo portrait painter Clifford Beck (1946–96). Like Beck, Yazzie says, "I'm a representational painter by choice." Beck was raised on the Navajo Reservation but went to art school in California. There he studied the work of Edgar Degas, which strongly influenced his style. Beck remained a deeply traditional Navajo all of his life, and the bulk of his oeuvre is a lovingly rendered tribute to his people and their traditional lifeways.

Mesa Verde and hangs at the Denver International Airport. Another commission, from the Albuquerque Academy, where Yazzie's two daughters were students, is a large oil of a scene from the Gallup Intertribal Indian Ceremonial. Yazzie was born in Arizona in 1946 and has lived in a predominantly Anglo world all of his life, and by his own admission, he knows little of the traditional Navajo world of myth and ceremony. He feels he is now at a transitional period in his creative life. "I've been doing European-style work so long that I'm ready for a change. I want to go beyond painting what I have seen. I'd also like to get into work that is more mental or abstract."

In 1998 Yazzie was a Dubin Fellow at the School of American Research and used his two-month residency to explore and reflect on his life at mid-career. One result has been the reawakening of an interest in his heritage. At this point, Yazzie does not know what future turn his life and career in art may take. Clearly he is searching for new directions and has the courage to effect them. With philosophical insight he ponders the unanswerable: "I don't know what I'm looking for in my life. Why do we stay here, in the Southwest? Would we still be Indian if we were someplace else?"

The resilient adaptability of his Navajo forebears is clearly expressed in Yazzie's art. He is eager to explore the wellsprings of his traditional heritage. For Yazzie, in contrast to most of the other participants in the Southwest Indian Painting gathering, "The Deep Remembering" will be part of his new direction. "I'm reversing the process and am now looking for roots," he says.

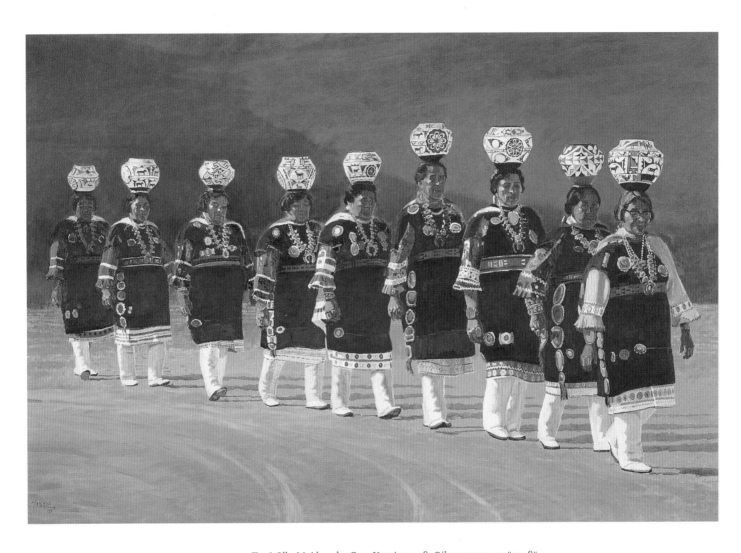

Zuni Olla Maidens, by Gary Yazzie, 1998. Oil on convas, 32" x 48".
This colorful scene resonates with the dignity and reverance of the ceremonial
dance.

Suggestions for Further Reading

In addition to the works listed below, a number of biographies, exhibition catalogs, and monographs on individual artists are available, as are two biographical directories.

The most recent directory is Patrick Lester's *Biographical Directory of Native American Painters* (SIR Publications 1995). This is an update of *American Indian Painters*, by Jeanne O. Snodgrass (Museum of the American Indian 1968).

Since 1983 the Heard Museum in Phoenix has published catalogs for its *Biennial of Native American Fine Arts Invitational*. Also from the Heard Museum is *Watchful Eyes: Native American Women Artists* (1994).

Among useful catalogs from Santa Fe's Wheelwright Museum are *Neeznaa: Emmi Whitehorse: Ten Years,* by Lucy R. Lippard (1991); *A Bridge across Cultures: Pueblo Painters in Santa Fe 1918–1932,* by J. J. Brody (1992); *Women's Work: The Art of Pablita Velarde,* by Sally Hyer (1993); *Translating Navajo Worlds: The Art of Narcisco (Ha–So–De) and Tony Abeyta* (1994); and *A Quiet Pride: The Art of Clifford Beck,* by Sally Hyer (1996).

The Institute of American Indian Arts in Santa Fe publishes catalogs and also provides excellent leaflets in its exhibition galleries.

The Museum of Northern Arizona in Flagstaff issues occasional publications on Native American painting, including Leland C. Wyman's *The Sacred Mountains of the Navajo in Four Paintings by Harrison Begay* (1967) and *Navajo Painting,* by Katherin Chase (1982).

Noteworthy biographies of Native American painters include Bill Belknap, *Fred Kabotie, Hopi Indian Artist: An Autobiography told to Bill Belknap* (Northland Press 1977); Margaret Cesa, *The World of Blue Flower, Pop Chalee: An Artistic Biography* (Red Crane Books 1997); Frederick Dockstader, ed., *Oscar Howe: Catalogue Raisonné* (Thomas Gilcrease Museum Association 1982); Samuel L. Gray, *Tonita Peña* (Avanyu Publishing 1990); Jay Scott, *Changing Woman: The Life and Art of Helen Hardin* (Northland Press 1989); Jeanne Shutes and Jill Mellick, *The Worlds of P'otsúnú: Geronima Cruz Montoya of San Juan Pueblo* (University of New Mexico Press 1996); Sallie R. Wagner, J. J. Brody, and Beatien Yazz, *Yazz: Navajo Painter* (Northland Press and School of American Research 1983); William Wallo and John Pickard, *T. C. Cannon, Native American: A New View of the West* (National Cowboy Hall of Fame 1990).

For discussions of contemporary Native American culture, various issues of *Indian Artists* magazine and its successor, *Native Artists,* are invaluable resources, as are *Native Peoples* and occasional issues of the Museum of New Mexico's publication, *El Palacio.*

Abbott, Edward Lawrence

1994　*I Stand in the Center of the Good: Interviews with Contemporary Native American Artists.* Lincoln: University of Nebraska Press.

Archuleta, Margaret, and Rennard Strickland

1994　*Shared Visions: Native American Painters and Sculptors in the Twentieth Century.* New York: The New Press.

Bernstein, Bruce, and Jackson Rushing

1995　*Modern by Tradition: American Indian Painting in the Studio Style.* Santa Fe: Museum of New Mexico Press.

Brody, J. J.

1971　*Indian Painters and White Patrons.* Albuquerque: University of New Mexico Press.

1997　*Pueblo Indian Painting: Tradition and Modernism in New Mexico, 1900–1930.* Santa Fe: School of American Research Press.

Curtis, Natalie

1907　*The Indians' Book.* New York and London: Harper and Brothers.

Dunn, Dorothy

1968　*American Indian Painting of the Southwest and Plains Area.* Albuquerque: University of New Mexico Press.

1977　The Studio: 1932–1937: Fostering Indian Art as Art. *El Palacio* 83(4):5–9. (Special issue on the Dorothy Dunn Collection)

Fewkes, Jesse Walter

1991　*Hopi Katcinas.* New York: Dover. (Reprinted from *Annual Report of the Bureau of American Ethnography*, 1903.)

Gritton, Joy L.

2000　*The Institute of American Indian Arts.* Albuquerque: University of New Mexico Press.

Hammond, Harmony, and Juane Quick-to-See Smith

1985　*Women of Sweetgrass, Cedar, and Sage.* New York: Gallery of the American Indian Community House.

Hannum, Alberta

1953　*Spin a Silver Dollar.* New York: Viking. First published 1945.

Henri, Robert

1960　*The Art Spirit.* Philadelphia: J. B. Lippincott. First published 1923.

Highwater, Jamake
1980 *The Sweet Grass Lives On: Fifty Contemporary North American Indian Artists*. New York: Lippincott and Crowell.

Hill, Richard W., Sr.
1992 *Creativity Is Our Tradition: Three Decades of Contemporary Indian Art at IAIA*. Santa Fe: Institute of American Indian Art Press.
1994 The Battle over Tradition. *Indian Artist* I(1):48–51, 90–95.

Hyer, Sally
1990 *One House, One Voice, One Heart: Native American Education at the Santa Fe Indian School*. Santa Fe: Museum of New Mexico Press.

Jacka, Jerry, and Lois Jacka
1986 *Beyond Tradition: Contemporary Indian Art and Its Evolution*. Flagstaff, AZ: Northland Press.

Kramer, Dorothy Dunn
1977 The Studio, 1932–1937: Fostering Indian Art as Art. *El Palacio* 83:4–5.

Lippard, Lucy
1990 *Mixed Blessings*. New York: Pantheon.

Loretto, Estella
1994 Pablita Velarde: Conversations with Estella Loretta. *Indian Artist* II(4):46.

Matthews, Washington
1897 *Navaho Legends*. Memoirs of the American Folklore Society, no. 5. Boston: Houghton Mifflin.

McCoy, Ron
n.d. *One Stream, Many Currents: Art without Reservations*. Santa Fe: Gallery 10.

McMaster, Gerald, ed.
1998 *Reservation X*. Seattle: University of Washington Press and Canadian Museum of Civilization.

Momaday, N. Scott
1966 *House Made of Dawn*. New York: Harper & Row.

Monthan, Guy, and Doris Monthan
1975 *Art and the Indian Individualists*. Flagstaff, AZ: Northland Press.

Peabody Essex Museum

1990 *Gifts of the Spirit: Works by Nineteenth-Century and Contemporary Native American Artists.* Salem, MA: Peabody Essex Museum.

Rushing, W. Jackson, III

1991 Authenticity and Subjectivity in Post-War Painting: Concerning Herrera, Scholder, and Cannon. In *Shared Visions.* Phoenix: Heard Museum.

Rushing, W. Jackson, III, ed.

1999 *Native American Art in the Twentieth Century.* London: Routledge.

Schmitz, Tony

1976 Film Makers' Reflections on the Production of the American Indian Artists Series. *Arizona Highways* 52(8):7 (August).

Seotewa, Ken

1992 Adding a Breath to Zuni Life, *Native Peoples,* Winter.

Seymour, Tryntje Van Ness

1986 *When the Rainbow Touches Down.* Phoenix: Heard Museum.

Sherman, Tisa Rodriguez, and Robert A. Yassin

1997 *Sola: Emmi Whitehorse.* Tucson: Tucson Museum of Art.

Tanner, Clara Lee

1971 *Southwest Indian Painting: A Changing Art.* Tucson: University of Arizona Press.

Trimble, Stephen

1987 *Talking with the Clay: The Art of Pueblo Pottery.* Santa Fe: School of American Research Press.

Tucker, Toba P.

1994 *Pueblo Artists: Portraits.* Santa Fe: Museum of New Mexico Press.

University of Arizona.

1959 *Directions in Indian Art: Report of a Conference held at the University of Arizona on March 20–21, 1959.* Tucson.

Wade, Edwin

1985 *The Arts of the North American Indian: Native Traditions in Evolution.* New York: Hudson Hills Press in association with the Philbrook Art Center.

Wade, Edwin, and Rennard Strickland

1981 *Magic Images: Contemporary Native American Art.* Norman: Philbrook Art Center and University of Oklahoma Press.

Acknowledgments

This book belongs to the ten Sacred Mischief Makers, the "Zennist Clowns" who gathered in New Mexico at the School of American Research—immortalized in Michael Kabotie's poem—and also to their visionary ancestors.

However, the book would not have come into being without the efforts of countless individuals. I am grateful to Douglas Schwartz, president of the School of American Research, whose farsighted and prescient vision has guided the School's programs, devoted to an ever-deepening understanding of the human condition. I thank Duane Anderson, vice president of SAR and director of the Indian Arts Research Center at the time the painting convocation was held, for his steady confidence and wise guidance. Dr. Anderson's leadership in promoting the IARC's ongoing investigation of the wellsprings of creativity is significant to the history of aesthetics.

Without four people at the Indian Arts Research Center, both the painting convocation and this volume would not have happened. Collections Manager Christy Sturm willingly shared her thorough knowledge of the IARC collections, as well as her wealth of friendships among Native peoples across the Southwest. My job was made easy by the precise and insightful notes of the convocation proceedings made by Lee Goodwin, coordinator of the IARC. Deborah Dodge Winton, with her ever-present smile and ready helpfulness, managed the myriad details of the convocation with ease and warmth. And Cindy Burnett, the 1999 Harvey W. Branigar Jr. Fellow at the IARC lent invaluable help; her notes of the gathering illuminated certain areas that had escaped my attention.

Friends at the SAR Press are also appreciated: For their wise editorial assistance, Jo Ann Baldinger, Joan O'Donnell, and Jane Kepp, and for her astute stewardship, Cynthia Welch.

Many people at institutions across the Southwest have responded willingly and helpfully to my queries. Robert Steele at *Arizona Highways* magazine; Ruth Noble at the Laboratory of Anthropology; Deb Hill, Tracy Murphy, and Tony Marinella at the Museum of Northern Arizona; Tatiana Slock and Paula Rivera at the Institute of American Indian Arts Museum; La Ree Bates, archivist at the Heard Museum; Bill Faust of the Faust Galleries in Scottsdale; and Denise Grogder, director of the

Lovena Ohl Gallery, Scottsdale. A special thank you also to Ron and Susan Dubin and to Lorraine Roturno.

So many friends and mentors throughout my life have illuminated my understanding of Native American art. While unnamed here, they are constant in my memory. And great thanks and love always to my two best friends, David and Sary.

—Katherin L. Chase

Picture Credits

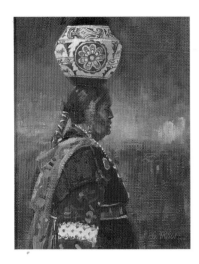

Untitled, by Gary Yazzie, 1998.
Oil on canvas, 7 15/16" x 10".
SAR 1999-4-9.

All photographs of items bearing SAR, IAF, or IARC catalog numbers are by Addison Doty unless otherwise noted.

"The Deep Remembering"
All photographs of the participating artists and the IARC convocation are by Mark Nohl and the staff of the Indian Arts Research Center, © SAR.

"The Indian Painting Tradition in the Southwest"
23: Courtesy of Bob and Marianne Kapoun, The Rainbow Man, Santa Fe, copy photo by Addison Doty; 24 top left: Private collection, photo by Addison Doty; 24 right: Photo by Lynn Lown, © SAR; 25: Courtesy of the Museum of Northern Arizona Photo Archives; 28: Kenneth M. Chapman Archive, SAR; 29: reproduced from the 1903 *Annual Report of the Bureau of American Ethnology* (J. W. Fewkes, *Hopi Katcinas,* 1991); 30: Courtesy of the Museum of Indian Arts and Culture/ Laboratory of Anthropology, Museum of New Mexico, Santa Fe; 32: IARC Archives, SAR, folder ACI:105.I; 33–34: IARC staff photos, © SAR; 35: Courtesy of the Museum of Northern Arizona Photo Archives, Clay Lockett Collection; 36 top: Photo by Lynn Lown, © SAR; 36 bottom: Kenneth M. Chapman Archive, SAR, photo by T. Harmon Parkhurst; 37: Photo by Lynn Lown, © SAR; 38: Courtesy of the Museum of New Mexico, neg. no. 73945, photograph by T. Harmon Parkhurst;

39: Courtesy of the Museum of New Mexico, neg. no. 70435; 40 top: Photo by Lynn Lown, © SAR; 40 bottom: Kenneth M. Chapman Archive, SAR; 41: IARC staff photo, © SAR; 42: Reproduced from *Arizona Highways,* February 1950, courtesy of *Arizona Highways;* 43 top: Courtesy of the Museum of New Mexico, neg. no. 3160; 45: Courtesy of the Museum of Northern Arizona Photo Archives, Katherine Harvey Collection; 47: Courtesy of Fritz Scholder and the IAIA Museum, MS28, photo by Walter BigBee; 48: Courtesy of the Museum of Northern Arizona Photo Archives; 49: Courtesy of Mateo Romero and the IAIA Museum, CO38, photo by Walter BigBee.

"The Artists"
All portraits of the artists are by Mark Nohl, © SAR; 55 bottom: Courtesy of the Lovena Ohl Gallery, Scottsdale, Arizona; 56: Private collection, courtesy of Jeanette Katoney and Bill Faust Gallery, Scottsdale, Arizona; 59: Courtesy of Linda Lomahaftewa; 60: IARC staff photo, © SAR; 61: Courtesy of Linda Lomahaftewa; 63 left: Courtesy of Felice Lucero; 65 bottom: Courtesy of the Museum of Northern Arizona Photo Archives, cat. no. CII07; 67 top: Private collection, photo by Addison Doty; 70: Private collection; 73: Courtesy of Mateo Romero; 74: Private collection, photo by Addison Doty; 81: Courtesy of the Heard Museum; 85: Private collection; 87: Private collection, photo by Addison Doty.